PRAISE FOR JESSICA BETTENCOURT AND *I ALMOST CANCELLED*

"Jessica is the real deal and one of the most inspiring entrepreneurial leaders I know. She is highly respected for her wisdom, success, and values. I admire how she loves people, loves Jesus and has overcome odds in her life. Through her story of humble beginnings, she will encourage you to show up and make your dreams a reality. If you want to learn from one of the best, believe me, you want this book."

—Crystal Archie

Multimillion-Dollar Entrepreneur, Founder of Treasured, CEO of More Precious than Rubies, Podcaster, and Lover of Jesus, her husband, and children

"If you didn't know Jessica personally, she may be the girl you'd be tempted to be jealous of. Her beauty, humor, grace, and honesty are qualities most of us desire, but by the first chapter of *I Almost Cancelled,* you'll feel like her long-time friend. Jessica has the gift of sharing her wisdom and experience genuinely, and yet you sense her desire is to assist you in avoiding pitfalls on your own path to success. This book is challenging, yet encouraging; a real 'how to' that puts the responsibility squarely on your own shoulders. Her confidence is inspiring, but more importantly, it's her belief that there's something great in all of us just waiting to be tapped into that leaves her readers motivated to reach the fulness of their potential."

—Kim Singletary

Entrepreneur, Wife of NFL Hall-of-Famer Mike Singletary, Mother to seven, and Cohost of Family Tip Fridays

"We love to hear Jessica speak. It's a treat, and she is a class act. Her love for the Lord and her Southern sense of humor shine through in all that she does. We always learn something from Jessica and find ourselves quoting her all the time. You will be blessed by this book."

—Debbi Coder and **Wendi Green**

Coauthors of Listen Sister, Multimillion-Dollar Entrepreneurs, Adoptive Moms, and Adoption Advocates

I Almost

CANCELLED

I Almost

CANCELLED

Showing Up When Fear Tells You to Stay Home

JESSICA BETTENCOURT

Jessica
BETTENCOURT

Jessica Bettencourt LLC
Bellbrook, OH

Jessica Bettencourt LLC

Bellbrook, OH

www.JessicaBettencourt.com

Send feedback to Info@JessicaBettencourt.com

Scripture quotations are from the ESV® Bible (The Holy Bible, English Standard Version®), copyright © 2001 by Crossway, a publishing ministry of Good News Publishers. Used by permission. All rights reserved. May not copy or download more than 500 consecutive verses of the ESV Bible or more than one half of any book of the ESV Bible.

Printed in the United States of America

Publisher's Cataloging-In-Publication Data

(Prepared by The Donohue Group, Inc.)

Names: Bettencourt, Jessica, author.

Title: I almost cancelled : showing up when fear tells you to stay home / Jessica Bettencourt.

Description: [Bellbrook, Ohio] : Jessica Bettencourt LLC, [2021]

Identifiers: ISBN 9781735761008 (softcover) | ISBN 9781735761015 (hardcover) | ISBN 9781735761022 (ebook)

Subjects: LCSH: Bettencourt, Jessica--Psychology. | Fear of failure. | Risk-taking (Psychology) | Self-actualization (Psychology) | Self-confidence. | Trust in God--Christianity. | Success--Psychological aspects.

Classification: LCC BF575.F2 B48 2021 (print) | LCC BF575.F2 (ebook) | DDC 152.46--dc23

Special discounts for bulk sales are available.

Please contact Info@JessicaBettencourt.com.

To my sweet Michael, thank you for always believing in me especially when I didn't believe in myself. Also, for loving me even though I drive you absolutely nuts. A special thank you to my four awesome kiddos. Thanks for encouraging me to pursue my dreams. I know you have all made sacrifices for the good of the family. I really don't know better humans and how you are all mine is truly a blessing I can't thank God for enough. To my precious momma, the most Christlike person I know, thank you for your example to love and serve others, always. Last but not least, to all the ladies who just need a swift kick in the pants or a big "atta girl" or maybe just the knowledge that you've always got someone in your corner, I see you. I dedicate this book to each and every one of you.

Don't get good at putting off hard things.

Keep a no-cancellation policy.

And watch good things show up.

GO BEYOND THE BOOK.

Let's wipe out self-doubt and step out with confidence—together. Get more free resources to help you live the life God intended for you at www.JessicaBettencourt.com.

CONTENTS

CHAPTER 1

Your Secret Advantage: The Power of Showing Up

For God gave us a spirit not of fear but of power and love and self-control.

—2 Timothy 1:7 (ESV)

Hold on a minute . . . are my Spanx showing? Thankfully, this is a book. Chances are my Spanx *are* showing. Or maybe they aren't. I never really know. Every time I walk out on a stage to speak, that is the first thought I have: *Are my Spanx showing?* Not, *Can they hear me? Is my microphone on?* Nope, I'm worried about my girdle. I usually just ask the audience. I can't seem to focus until I do. I tell myself not to worry and not to point out anything that isn't going right, but getting up there and having my Spanx show feels all-consuming in my mind.

Isn't it funny the things we focus on? I have a friend who gets comments every day from acquaintances and strangers alike about her size. "You're so skinny! Grab a snack," she's told. Now, I know she eats a

hearty three meals a day. She's fine. I mean, I wish I could eat the way this girl does. Still, every comment dents her confidence. So much so that she will purposely eat in front of people to prove that she doesn't have an unhealthy relationship with food. Another friend has the opposite problem. She gets self-conscious every time she puts on a dress or eats a meal with others because she's afraid she's too fat. Two different people, the same fear of being judged, the exact opposite reason. It's ironic.

As I was doing research for this book, I learned the strangest thing about what most women worry about. I'm talking way deep down behind all the motivational memes they share on social media, the inspirational quotes they stick on the kitchen walls, and the Bible verses they know by heart. Most women today fear

- asking for what we want . . . and getting it;

- being overqualified . . . and being unprepared;

- feeling like a failure . . . and achieving success;

- being judged . . . and being put on a pedestal;

- not being liked . . . and liking someone who isn't right for you;

- sacrificing family time for work . . . and giving up two incomes to stay home;

- taking a career break . . . and leaving the kids at day care;

- ending a friendship . . . and making new friends;

- getting older . . . and getting stuck; and

- changing things . . . and leaving things the same.

These fears seem like contradictions, don't they? So what's the common theme among them? It seems we're scared not only of shooting for what we want and missing but also of *getting* what we want. What if we get it, but it doesn't make us happy? Then again, if we don't get our heart's desire, it's like we've proven we don't deserve it. Double whammy.

It's crazy, isn't it? It's like we're trained to fear everything. We could blame social media, the news, gossip, society at large—heck, some-

times girlfriends, close family, and even your spouse can make you feel unworthy and give you an excuse to bail. Take your ball, leave the playground, and go home. It's just not worth the risk, fear tells us. Well, I think fear is tricky. It can paralyze you or motivate you. I choose to let it motivate me. They say keep your friends close and your enemies closer. Think of fear as your frenemy.

What one woman fears, another has been working toward her entire life. What one is dying to have in her life, another hates every minute of. Yet the very things we fear are often nothing to be afraid of at all. We'll never know that if we don't take a shot. Think about it. If you're afraid of putting yourself out there to meet other like-minded people *and* you're terrified of the prospect of releasing your old college bestie from your life, what's going to happen? You'll get (and stay) stuck. Nothing against your bestie. You're just going in different directions now. Maybe you don't have as much in common as you used to back in your sorority days. Like many women, you might look for shortcuts around fear. Maybe you wait a few days to call her back. Maybe you find a reason to skip the hiking meetup you've had on your calendar for a week. Instead, you stay home and binge-watch TED Talks about making friends. All you're doing is going in a circle. Real shortcuts don't exist. Trust me, I've looked for them myself.

Before I started my first business, a mentor said to me, "Let's talk about what you're good at." I thought she was about to go over my list of accomplishments. You know what she told me?

"Jessica, you're good at putting off the hard things. You look for solutions and find temporary inspiration to quiet your fears. Let fear push you to work hard."

Stings a little, doesn't it? I'll be the first to admit that I was focused on the wrong thing. I was looking for the secret sauce of success. A magic bullet. Maybe a partner to hold me accountable. Someone to tell me what to do. Anything and anyone to shortcut my fear of failure. Besides, what would an accountability partner hold me accountable for? Nothing. Because that's what I was doing—nothing.

My high school days are a great example of the way women go after

their heart's desires. My sister was a star athlete. She wasn't simply talented and happened to be a starter. No, she was *phenomenal*. She played multiple sports well. She was our state free-throw champion two years in a row. Being her sister and being taller than her, everyone at school thought I could be a basketball superstar. The problem was . . . I wasn't. I was terrible. The real problem was that I never tried to be great. Not even good, for that matter. I was so afraid of not being as skilled as she was that I didn't even try. Looking back, I don't think I could have ever been as good as her. I don't have the natural talent she had or the willingness to work the way she did to get better. But I do wonder if I could have been good enough to make the team. Imagine if I had. How different would high school have been if I'd gotten to share that experience with her? OK, I might be romanticizing this alternate history a bit. It would have been nice for me. But based on the year we played on the same softball team and I caught only one ball all season, I don't know if it would have been fun for my sister.

Here's the deal. I'll never know because I chose to stay on the sidelines. I didn't show up when I had an opportunity to try. Maybe I never would have been a star, but being a part of the team would have been a blast. But I got anxious when I thought about practicing basketball. Shooting airballs, embarrassing myself, looking like I didn't belong . . . scary thoughts. Faced with fears, what would you rather do? Go to the open gym, try your best, and see what happens? Or stay home and always wonder what might have been? I learned a big lesson in high school. I never became a great athlete, and it's still something I struggle with as an adult. I want to play recreational sports, but I often tell myself I'm not good enough. But I decided to start showing up. It's not basketball, but I took up tennis and now enjoy pickleball. It feels good to compete. It feels great to be on the court with my kiddos. I'm certainly not a star, but I like to think I hold my own.

The point is, it's easy to do the simple stuff and avoid the effort. Because effort is scary. What if you work hard but don't get the payoff of a higher income, a better marriage, a fulfilling relationship, or a body you love? Or worse, you *do* get it . . . and you lose it? Women tend to fear

loss just as much as the prospect of massive gain. So what do we do? We settle. We settle for an OK income, an OK marriage, OK friends, an OK body, and an OK life. You see, "just OK" isn't risky. Fear-based self-talk tells us, *If you go for more and you get it, then what you've sacrificed will be for nothing if you lose it.* Fear promises you that it's better to have something than nothing. *Don't put yourself out there,* it says. *If you express yourself and are rejected, you'll feel stupid. Too risky. Better to lie low and stay quiet than to stand up and embarrass yourself.*

This is what people mean when they talk about a fear of success. It's a misnomer, really. The idea of success conjures up this image of what's required of you. What if you can't maintain that image? Fear of success isn't fear of *actual* success—it's the fear of succeeding and not being able to hold on to it. It's worrying that you'll change and become someone you don't want to be. It's being afraid of what that success could cost you. Many women are afraid of losing weight because they think they'll lose their girlfriends. Some are afraid to improve their diet because they don't want to make their lunch group uncomfortable. It's easier to stick with the status quo. *You think you're better than me because you're skinny?* Even if they don't say it, you dread them thinking it.

I catch many people living in a state of "I could never." In my business, a lot of women tell me, "I could never speak on stage the way you do. I could never work the number of hours you do. I could never juggle my family life the way you do. I don't have the kind of support you do. I could never lead thousands of people like you do. I can barely lead three people." They make up these requirements for success and tell me they could never meet them.

I see countless women who spend precious time fighting their fear with inspirational sermons, motivational books, and other feel-good messages. Sure, the fear gets quiet for a short while, but they don't make progress. Tomorrow, the fear of the unknown will return. If you don't show up when you feel like staying home, you rob yourself of the chance to stare your fear in the face. And you know what? If you face your fear, I can guarantee that you'll find you don't have that much to be afraid of.

Maybe you're nodding along because you know this. You know that putting yourself out there can come with a little anxiety but also a big reward. The fact that you picked up this book tells me you're *over* listening to the spirit of fear. You're hungry for more. You're done settling. Just OK is just not good enough. You're ready to reach your full potential in all areas of life. But how? It's far easier said than done, right? Not necessarily. Does that mean it's possible to numb fear altogether? I wish. But what you can do is take that fear and make it your friend. It's OK to be afraid. You're allowed to fear what could go wrong. You're even allowed to let fear drive you—as long as it's in the right direction. What does that look like? The first step is pretty simple, really. Just show up. If you do nothing else, just show up. You don't even have to feel like it. Simply stepping out when nobody else does gives you the advantage over fear that you need.

This isn't just a cute analogy. Did you know this showing-up advantage can be measured? Let's look at the game of chess. In the last 150 years of professional chess matches, the player who goes first wins more than half the time. Something like 56 percent, actually.[1] That's regardless of skill, by the way. If one of your chess pieces shows up on that battlefield first, the odds are already in your favor.

In business, we have what's called the first mover's advantage. The first product to show up in the market wins. Even if it's crappy, costs a lot, and attracts competition. Even if copycats make your product after you and make it better. If you're first, you can still win big. And you know what you have to do to be first?

Show up.

That's all I'm asking you to do. Show up when fear tells you to stay home. If you just show up, you have a pretty big chance of winning. All the while your competition stays home (because they haven't read this book yet).

Everything I've written here is about how to start showing up and keep showing up to sustain your momentum. If you keep showing up,

1 Jonathan Rowson, *Chess for Zebras: Thinking Differently about Black and White* (Berkshire, England: Gambit, 2005).

you'll rack up a string of wins you never even dreamed of. That's how I've lived my life. I just show up no matter how I feel. For as long as I can remember, I've been riddled with social anxiety. Most people wouldn't know it. If I accept an invitation to a social gathering, I almost always dread it and wish I'd said no. I agonize over it and think up a thousand excuses to cancel. But because I said yes (and because I have a no-cancellation policy), I go.

Here's the crazy part. I always have a great time. *Always*. So history doesn't tell me I should have stayed home. Quite the opposite. But time and time again, I accept, I dread it, I fret over it, I go, and I have a great time. I love meeting people. I love learning their stories. But I *loathe* small talk and don't like feeling vulnerable. I enjoy my time with people. It's before and after when there's crazy dialogue in my head. Before going, I imagine everything that could go wrong. And on the way home (and sometimes for days after), I overthink all the ridiculous things I think I said. Still, I'm always glad I showed up. Because I keep getting invited back, I probably should stop dreading, fretting, and overthinking.

Life has taught me to show up no matter what. No matter how I'm feeling or what I'm thinking. This applies even when I have no idea what I'm doing. For example, I started a professional photography business with zero photography experience. Bella Baby Photography. I can't say it was my idea, though. An acquaintance I met over dinner shared with me her notion to bring an artistic, journalistic style to in-hospital newborn photography. I had zero interest in partnering with her but loved the idea of cheering her on. So when she asked me to join her in business, I said, "No way!" I hadn't even taken pictures of my own children. The last thing I wanted to do was upload, download, edit, and whatever else I needed to learn to take professional pictures and own a photography business. I told myself I couldn't learn. Then after some long conversations with my husband, I agreed to help with the marketing. But no editing, uploading, or photographing.

Ten short weeks later, I found myself photographing babies in the hospital, editing, uploading, downloading . . . all the fancy things. You know why that happened? Because I showed up. Every day, feeling like

I had no idea what I was doing, I decided to learn. I chose to stop saying I wasn't smart enough. I told myself, *You* can *learn this*. And you know what I found out? I was good at it. OK, don't check my early work. I wasn't winning any awards. But I was coachable and determined. Those two qualities helped me overcome my fears. I did get better and eventually got great. Of course, as all good stories go, a major curve ball came my way when my husband, Michael, lost his job. I needed to take baby photography from just a thing into a real income.

I'll be honest. My knee-jerk reaction (thanks to the critics) was to go back to a stable, "normal" corporate job that pays every hour by the hour. I just didn't want that for me or for my family. No more trading time for money. The thought of that made the fear of the unknown palatable. See, I knew what clocking in felt like, and I was willing to face *anything* to avoid doing that again. So I upped my game. I made more phone calls, and I got more efficient so that I had more time to market my services. I practiced my photography skills so that I could improve my sales and be proud of my product. Of course, I still had all those fears running through my head.

What if people hate my pictures? Or what if they like them but aren't willing to pay much for them? What if they are, and I end up with so much business that I burn out and break down?

For the five years I spent building that business, fear kept talking. But I kept walking. Walking into hospitals, offering to take adorable photos of newborns, and walking out with clients. I was willing to do whatever it took to grow my income and to give my family options. I was so determined and disciplined in my work, I barely did anything that didn't bring me closer to a comfortable salary. I had a survival mentality. Looking back now, I wouldn't change a thing. Growing my territory and building that business brought me to a place of gratitude. It brought me to a place of time and financial freedom. Those five years of sacrifice were worth it. And I wasn't successful because I was special. *Anyone* could have done what I did. My town had hundreds of seasoned professional photographers who could've offered to take pictures of those beautiful new families. For one reason or another, they didn't show up. But I did. Today, with additional partnerships like mine, Bella

Baby is a nationwide brand with over $40 million in annual sales. I am so proud to have been the first partner in the business and to have helped lay the foundation for what it is today.

If I had known the number of hours I would be working, the number of nights I would be traveling, and the number of meals I would miss with my family, I probably would have been even more afraid. Then again, if I had had any idea of the personal fulfillment that a successful business could bring, I might have started sooner. That's why I went and did it again. Once Bella Baby had an infrastructure in place and didn't need my full attention, I stepped into a premium skin-care company and quickly rose to be one of the top consultants in the world, with a team of over eighteen thousand, totaling more than $24 million in annual sales. This didn't come easy. I worked really hard, but again, although showing up in a new venture proved to be scary at times, it was so worth it.

When people who know my story hear me speak, they're often surprised to learn I've had the same fears they do. I've just decided that what I'm supposed to do is more important than that fear. I've realized that our real fear should be of *not* showing up. And that's why I wrote *I Almost Cancelled*. This book is a gentle nudge of "just do it" with a boxful of "here's how" and a big dose of "you got this." If you are willing and able, you can accomplish anything you choose to do. Through twelve lessons taken from the path that I and many successful, fulfilled women have walked, this book will show you how to

- achieve your full potential;

- believe in yourself;

- overcome fear of failure *and* fear of success;

- set small goals that lead to big achievements;

- stretch yourself without exhausting yourself;

- build true-blue, ride-or-die friendships;

- recognize your God-given talents and do something with them;

- take average and allow God to make it great;
- wake up each morning with a tackle-the-day mentality;
- see opportunities where others see obstacles;
- guard your time, your sanity, and your heart;
- find and take the right next step over and over;
- be content while being willing to grow;
- stop comparing your definition of success to others';
- conquer complacency and excuses; and
- make the right change when things don't go as planned.

During our time together in this book, you'll wipe out self-doubt, rage with courage, and recognize that no one can hold you back if you're willing to work for what you want. That's the key right there, isn't it? What *you* want. How I show up successfully as a woman and how you show up successfully as a woman can look very different. I shouldn't try to live up to your version of success, and you shouldn't try to live up to mine. But we often do anyway, don't we? Well, not anymore. Because when you see how my journey began, you'll realize that success is available to anyone. It doesn't matter where you came from or what you set out with; you just have to be willing to start.

CHAPTER 2

Minus $42 to My Name: A Love Story

For this light momentary affliction is preparing for us an eternal weight of glory beyond all comparison.

—*2 Corinthians 4:17 (ESV)*

When people hear I'm from Tennessee and my husband, Michael, is from Massachusetts, they always ask, "How did you meet?"

It depends on who is telling the story. If you want the truth and the long, interesting version, ask me. If you want the fun version, ask Michael. He loves to say with a fist pump and in a loud voice, "Spring break '91, baby!" And although this is true, it's hardly true in the way he makes it sound.

Let me give you the scoop, but I'll be honest, I can't believe how outrageous this all sounds. I lived it, and it didn't feel crazy at the time, but if my daughter tried to pull something like this, I would absolutely wring her neck. But it was a different time back then, and it all worked out, but goodness, it does seem bananas.

I was seventeen, a senior in high school, and I wanted to go on spring

break in the worst way possible. Two problems: The first was that I couldn't afford to go. But the second and most difficult challenge was my parents. No way on earth were Quenton and Diana going to allow their respectable daughter to go gallivanting across the country to romp around in a bikini on a beach somewhere in Florida. That is exactly what I wanted to do, and I couldn't see how I would ever be able to make it happen.

As it turns out, I've always been a bit of a salesman. Who knew my best girlfriend's mom's love of a TV evangelist would be just the thing I needed to land myself on that beach in Florida? Pay attention, you're about to experience sales training 101!

One day while Jody's mom, Sharon, was watching the well-known healing TV evangelist Benny Hinn, I saw that his home church in Florida was hosting a revival the same week we were on spring break. I said to her, "Sharon, we should go to that. We should go see him in revival. It's the week we're out of school. I think it would be amazing!" I didn't dare mention spring break, but I made sure she knew how excited we would be to attend revival.

I can't remember how all the conversations went, but we convinced her and my parents to let me go. I couldn't believe it. I was walking on a cloud, and I needed this trip to happen as soon as possible. I wanted to be on the road before my dad could change his mind. The day finally arrived, and we were on our way.

Now, this is where spring break '91 isn't what you might be envisioning. Michael loves to imply it was all things spring break, but heavens to Betsy, it was far from it. This is how it went down. Each day the girls—there were three of us—would hang out at the pool, walk on the beach, and people watch until around four o'clock, when Jody's mom, Sharon, would say, "Girls, get your showers and get your dresses on. We need to leave for revival in an hour." Yes, every night of spring break, I attended a Benny Hinn revival. Read that sentence again and let me hear an amen from my sisters in the back row! Absolutely crazy, but I didn't care. I was thrilled to be in Florida.

On the morning of our last day before heading back to Tennessee, we were walking on the beach when the most gorgeous guy I had ever

seen started talking to us. I know what you're thinking. *How sweet. Love at first sight.* Nope.

He asked, "Where are you from?"

"Tennessee," I replied in the thickest southern drawl I didn't even know I had.

He said, "You talk funny." I was completely taken aback and thought he was so rude. Who says that to a girl he's just met on the beach?

As this conversation is unfolding, up walks the cutest blond-haired boy with a long-sleeve shirt on because he got a sunburn the day before. He looked a bit dorky, but he was so adorable. He jumped into the conversation and said, "I love the way you talk. What's your name?"

I replied, "Jessica, and these are my friends Jody and Krystal. What's your name?"

They both replied, "Mike" and then laughed.

"Wait, you're both named Mike?" (I pronounced it Miiike, sorta like Mac.) I looked at the tall, dark, gorgeous fella and said, "OK, how about I call you Miiike, and I'll call you Miiichael?" My Michael later said he was thinking, *Call me whatever you want, just keep talking.* He had never heard a true southern accent before, and he was smitten.

As simple as this sounds, it was a quick chance meeting and then we moved on. We only chatted with them for a bit, then walked on to get an ice-cream cone. Michael came over to where we were standing and asked if we wanted to do something later that evening. Of course we wanted to hang out with them, but there was no way I could tell him we had to go to revival first.

I said, "Give me your number. If we don't have anything better going on, I'll call you." I was a bit overzealous in my younger days and didn't make any apologies for it.

Off to revival we went, and when we returned, we asked Sharon if we could go to the beach. She said yes, and I beelined for a pay phone. I dialed his number, and a guy named Vince answered. I asked for Miiichael, and he yelled, "Hey, Tennessee's on the phone!" I told him where we were, and Michael arrived in just a few minutes.

We had such a great evening talking with him. When he asked where we went to school, I answered "Cumberland," although I conveniently

left off "County High School." I mean, he was a college freshman. I didn't want him to know we were only in high school. Looking back, this is so funny to me. He was just a year ahead of us, but he seemed so mature compared to the boys we knew back home.

As we got close to curfew, I told him we had to get home. He asked if he could walk us back, but I knew that was not a good idea. I didn't want him to know we had a chaperone or my cover would be blown. Thankfully, he was a perfect gentleman and didn't press the issue. Before we left, he asked if he could have my phone number. I gave him my post office box instead and left it at that.

Well, isn't he a clever one. He called 411 and asked for the phone number for any Gayharts in the area. The operator gave him the numbers for Quenton and Wade, my dad and my grandpa. He picked the right number, and he got my voice on the answering machine. He left the nicest message that was retrieved by my mother.

As we left for Tennessee, I assumed I would never see him again, but I had a lot of fun daydreaming about it. Just after crossing the Georgia line, we stopped to get a drink. I used a pay phone to call my mom to let her know we were on our way. She said, "Jessica, a young man by the name of Michael Bettencourt left a message on our machine. Who is this boy?"

I said, "Oh, Mom, he is the nicest guy. That's why I'm calling. I'm not with Sharon and the girls. I'm with him. We eloped!" She did not think that was funny.

"Jessica, put Sharon on the phone right now. I want to hear her voice so I know you are still with her."

"Don't worry, Mom. I'm with Sharon and we're on our way home, but *please* save that message and I'll explain later."

I had no idea how much explaining I was going to be doing over the next few years.

After I returned home, I talked with Michael as often as I could. He was in military school, so his time was limited, and I was under my dad's rule, so my phone time was limited. Especially if it came with long-distance charges. Some of you reading this will never understand the stay-

ing power of a relationship that weathered long-distance charges. Let me tell you, that's true love!

As summer approached and I graduated high school, Michael and I wrote letters back and forth, both sharing our thoughts about how we might see each other again. It seemed like a long shot. He had a short summer because he was headed to the Air Force Academy, and my parents were never going to allow me to visit some boy in Massachusetts.

Well, as fate and an incredibly resourceful girl would have it, I did figure out a way to see him again. This is where you are going to want to lock up your daughters and throw away the key. I can't believe I did this!

My uncle gave me $350 toward a girls' trip for my graduation, and rather than plan that trip, I visited the local travel agent in town. I convinced her to book me a flight from Nashville to Hartford, Connecticut, for June 3. Now I just needed a ride to the airport. I considered not even telling my parents, but then that seemed crazy. Yes, that is the only part that felt crazy to me.

I knew I had to tell them, so one evening I decided to drop a bomb at the dinner table.

My brother, Jeff, was home from college. He usually had my parents' attention for one reason or another, so I was hoping his presence would be a distraction. I waited for what I thought was the perfect time, and I calmly said, "I wanted to let you all know something. Um, Jeff, can you pass the peas? I wanted to let you know—ahem." I cleared my throat and avoided eye contact. "Mom, can you pass the ham? I wanted to let you all know I'm not going with the girls on a trip. I've decided to use the money to go see Michael."

Before I could finish with "I bought my ticket today," my father pushed away from the table and said, "Young lady, you have gone too far. You are not going to fly off to visit some boy you don't even know!"

"What? I do know him. We've been talking for months. I can't believe you're treating me this way. I'm seventeen years old, and I have never given you any trouble." I bolted to my room in hysterics. Very dramatic! I hope you all heard that loud and clear. Do you see how ridic-

ulous my parents were being? I was seventeen years old, for goodness sakes. Seventeen years old . . . what was I thinking? Heaven helps us all.

Thankfully, my mom was always the calm voice of reason. She knew I had been talking to Michael and that we'd been writing letters for several months. Her gut told her he was a nice young man. She came to my room as I was on the phone with him. She said, "Let me talk to Michael." I was mortified, certain she was going to embarrass me and tell him I couldn't come, or worse yet that we needed to stop talking, but that isn't what she said.

She said, "Michael, tell me a little bit about your family." This is where I should have prepared him to lie and say he was Methodist. If it came out he was Catholic, I promise you this back-row Southern Baptist girl was going nowhere. Thankfully, she didn't ask about his religion, at least not that night.

They had a nice conversation, and he said, "Would you like to talk to my mom? I can go get her." It was late and my mom didn't want to wake her, but she did arrange to speak with her the following day. After talking with his mom, Judy, and learning she was a schoolteacher and how excited they were to have me as a guest, my mom agreed to let me go. I'm not sure my father was ever on board, but somehow we got it past him.

The day finally arrived for me to travel. Thankfully, my mom agreed to drive me to Nashville. On the way, she gave me every lecture you can imagine. She kept saying over and over, "If you get there and anything seems off, anything at all, you get on the next plane headed south and I will pick you up wherever you land. If you feel uncomfortable for a minute, young lady, you get to the airport and I will be there to get you. Do you understand?" I understood, but I had no intentions of leaving early. I was so excited to see sweet Michael, and I was all about this thrilling adventure.

After disembarking from the plane, there stood the cutest boy I ever saw waiting to greet me. He was smiling ear to ear. I'm sure I looked like a giddy schoolgirl seeing him again. He gave me the best hug and then introduced me to the friend he brought along, Forrest. He later ad-

mitted he was nervous about the drive home and wanted to have someone to help with the conversation.

The drive felt like a dream. I couldn't believe I was in his car. I couldn't believe I was with him. As we approached his house, I did get a bit of a pit in my stomach. The street was lined with beautiful stone walls and canopied trees. There was a break in the stone and a beautiful winding driveway led up to a gorgeous Cape Cod-style home. It looked huge to me; my parents' house could have fit in the garage. It had a giant American flag draped beautifully on the front, and there were candles in each window. I thought, *Oh my goodness, he has brought me to a bed-and-breakfast.* I had read about New England bed-and-breakfasts, and I knew I was not supposed to be staying at one.

Hesitantly, I asked, "What are we doing here?"

He replied, "I live here."

Whew! OK, calm your nerves. What was I worried about? Maybe all the crazy lectures my mom gave me on the drive to the airport? Of course he lived there. Where else would we be?

His parents' home was breathtaking and was maybe the nicest home I had ever stayed in. They had a beautiful guest bedroom set up for me and a vase of flowers with a handwritten welcome note. That alone blew my mind. I didn't know anyone who had an extra bedroom in their house just waiting for a guest to arrive. I expected to sleep on a pull-out sofa or something. It all felt so fancy.

The time seemed to fly by, it was such a great week. We explored his small town and ate at Subway, one of two chain restaurants there. I dumped soda in my lap, and Forrest was with us to experience that humiliation. One day we went to Boston with his parents. I had never seen a city like that before. It was incredible. I practically needed a translator to understand the gentleman driving the Beantown Trolley. To be fair, he couldn't understand me either. We visited all the historic sites: Quincy Market, Boston Common, Faneuil Hall, and the Freedom Trail. I was on cloud nine.

Now the hard part. It was time to go home. I experienced a flood of emotions and had a lot of questions running through my mind. *When will we see each other again? Is it even worth trying to stay in touch because he was headed to Colorado to attend the Air Force Academy and I was headed to Middle Tennessee State for my freshman year of college?* I liked him. I had never met anyone like him before. I knew I wanted to see him again but decided now wasn't the time to worry about it. Not to mention I lived by the phrase, "Where there's a will, there's a way." Much to my parents' dismay.

As we drove to the airport, I could tell he was a little nervous. Finally, he broke the silence and said, "I wish there was a way for us to see each other, but I want to be fair to you. You're headed off to college, and I know you're going to want to date other guys—"

"Wait just a minute. Hold up, Michael Bettencourt. You don't get to make that decision for me. I will decide if I want to see other people, and I don't want to see other people. Do you want to see other people?" I declared quite boldly.

Now remember, he was going to an almost all-guys college at that time, and he didn't have a ton of opportunities to hang out with many girls.

He assured me that he didn't want to see other people, but he was also unsure of how we could make it work. How would we even be able to see each other again?

I told him to let me worry about that. Remember, I was the girl who sold her Southern Baptist parents on a spring break revival trip. I could figure this out. Michael had his feet firmly planted; he knew what he wanted to do. He had a solid plan: go to the academy, get his pilot's license, buy a fast car, and date pretty women. Isn't that adorable? Little did he know what was coming his way.

He was all smiles the rest of the way to the airport. He said, "OK, so we're dating then? Long distance?" That was my first indication of how sweet and kind he was as well as a bit dorky. I didn't care. I thought he was amazing, and I didn't want to see anyone else. I liked everything about him, dorkiness and all!

We made it work for the next year. His parents were so kind. They offered to fly me out with them for parents' weekend in Colorado. It was amazing to see him and to experience the Air Force Academy. It gave me a whole new appreciation for what he was doing. It was tough as a freshman. He had very few freedoms and a heavy academic load, which left little time for anything outside of military and school demands. We saw each other over Christmas break and then it was the long haul until summer, when we figured out a way to see each other for a short visit at my parents' home.

Before he left to return to Colorado, I got the bright idea that I would transfer schools and move there. Remember, this was long before the internet, so I asked him to grab a few of the rental property magazines and give me a list of local colleges. I'm not sure he thought I would do it, but he was excited at the prospect.

I spent a good amount of time planning and researching before realizing I could not afford to move and go to school. I would go to bed discouraged and then wake up with a new plan, which required more researching. Finally, I found a school I could afford. It was a small community college, and with a little creative writing, I managed to get in-state tuition. I know what you're thinking. *This girl is either a con artist or absolutely brilliant*. Let's ride the brilliance wave. I promise, I can explain everything.

Now to figure out where to live and how to get myself across the country. This became a daily numbers game. After work each day, I would get a pen and paper and tally all my expenses. If I could keep my rent below a certain amount, how much would I need for groceries, gas, and other incidentals? On my early tally sheets, I remember I always included cable TV. For goodness sakes, I could barely afford to eat so there was no way I was getting cable. Dreamer, always a dreamer.

After I finally got it worked out in my head, it was time to drop another bomb at the dinner table. This time I knew it was going to cause a war.

Again, I picked a time when my brother, Jeff, was home. I was hoping this was the night he announced he was becoming a monk or getting a tattoo. Nope, nothing. As we sat down to dinner, I said,

"Jeff, can you pass the peas. I wanted to let you all know something."
Again, I kept clearing my throat and avoiding eye contact. "Mom,
can you pass the ham? I have decided to transfer schools. I enrolled
in Pikes Peak Community College and will be moving to Colorado
in late August."

Silence.

"I found an apartment, and I'm ready to sign my lease. I'll be living
alone until school starts and I make some friends. I'm hoping someone
will help me move my things out there when the time comes."

Silence.

When I was finally ready to make eye contact, I saw that my mother
was looking at my father. My brother was looking at his plate, so that
left me only one choice. I had to look at my dad. He was not happy.

In a firm voice, he said, "Jessica, you are making a mistake chasing af-
ter a boy you barely know. This is not acceptable, and I do not support this
decision. How are you planning to pay for this, because if you leave Ten-
nessee, I'm not paying for college. How are you going to support yourself?"

This was the first of many heated discussions. All of them ended with him
telling me I was making a mistake and he was not supporting my decision.

Then he dropped a bomb of his own. One evening he called me into
the living room. "Have you figured out what car you're taking with you
to Colorado?" I assumed I would be taking the car I was driving. It was
a 1989 Nissan Maxima with a stick shift, and I loved that thing. He
quickly informed me that it was his car, and it wasn't leaving the state.
Now I had to go back to the tally sheet. How in the world was I going to
cover the expense of a car?

I searched high and low for a used car I could afford. Then I learned
the bank would not give me a loan on a used car but they would for a
new vehicle. I went to work looking for the cheapest new car I could
possibly find. I landed a sweet three-cylinder Geo Metro with no AC,
crank windows, and barely enough room to fit anyone in the back seat.
It was $6,000 brand new!

Here was the only problem: I had not planned on this expense. The
only way I could afford a down payment, my first semester, and the

apartment security deposit was to work every extra shift I could pick up at my job. I was a unit secretary at our small hospital in town. I was a fill-in, which meant I didn't have a specific floor and I didn't have a set schedule. I worked wherever and whenever they needed me. I let the other secretaries know if they needed a shift off or a vacation covered, I was their girl. I found myself working all kinds of shifts with very little time off. I worked a twenty-two day stretch, from 7:00 a.m. to 3:00 p.m., coming back at 11:00 p.m. to 7:00 a.m., and working the night shift for a few days, only to be followed by a 3:00 p.m. to 11:00 p.m. shift. Some days I would work 7:00 a.m. to 11:00 p.m. I took every shift that was open, even if it meant I had only a few hours off before changing floors and doing it all over again. I loved working maternity, I didn't like te-lemetry, and I was too high strung for the ER, so they rarely let me work down there.

I did this right up until it was time to leave for Colorado. I loved that job; it gave me a great glimpse into the real world.

On moving day, my dad had softened toward the reality that I was going with or without his blessing. He agreed to let my mom and me use his truck to move the things I had acquired for my apartment, and he would follow behind in my Geo Metro. It was so hot, and he had his fair share of problems driving that clown car across the country, but I was so grateful that he agreed to help. I was excited for them to see where I would be living and to get an idea of the thrilling journey ahead of me.

When we arrived in Colorado, both my mom and I were pleasantly surprised with the apartment I had rented sight unseen. It was very mod-est, but it was clean and I felt pretty safe—that is, as long as I was in and had the doors locked by about 4:00 p.m. each day.

My parents stayed a couple of days and then it was time for them to leave. I was eighteen years old and I was in that apartment all alone. Michael was at the academy, about forty minutes away. I cried. *What in the world have I gotten myself into? I'm not sure I can do this. How am I going to cover all my expenses? What if I can't make it? What if I need my parents to come back and get me?* I laid awake the first night, tossing and turning, listening to every noise. I was certain someone was

breaking into my car, then I was sure someone was going to realize I was living there alone and break into my apartment. I let my imagination run wild. I was scared. There are two feelings I hate: feeling hungry and feeling scared.

Over the course of the next few weeks, I landed three jobs. I needed to work as much as possible to make sure I could cover my bills. I was also going to school, but honestly, it was hardly my top priority. I needed to do well in school, but I also needed to eat. Michael was kinda oblivious to how meekly I was living. I didn't let him know how tight my budget was. He took me to dinner every Saturday night at a local Chinese restaurant. I would order a huge meal and take most of it home for leftovers throughout the week. I ate the same meal for lunch Monday through Friday at the school cafeteria. For $1.25, I could get a large bowl of chili, and I would take as many cracker packs as I could fit on my tray—usually about fifteen—without being completely embarrassed.

One night on the phone Michael said, "If they serve chicken patties one more Thursday, I don't think I can even eat." I was so irritated with him. I would love for someone to be cooking my meals and serving them to me hot and fresh.

I told him, "Please don't complain about the hot meal being prepared and set before you three times a day." It was a small glimpse into what I was dealing with, but my pride didn't want him to know much more.

Before I left for Colorado, I overheard my dad say to my mom, "We'll let her go. It will be harder than she thinks and she'll be back before Christmas." I remember thinking that he shouldn't underestimate me. I wouldn't be back. I was going to make it on my own. I wonder if I hadn't heard him say this if I would have had the grit to stick it out. I was stubborn, and I wanted to prove myself. This was just the nudge I needed to withstand all the hardships.

This was my life for the next two years. I found a roommate, Robin, which was the absolute best thing. I met her on campus in the chemistry lab. She was a riot, and I loved living with her. At the end of our time on campus, we couldn't get our transcripts because we had such a large lab bill for things we had broken! It was expensive being friends with

her, but it was totally worth it. Having her as my roommate was a life-line. She may never know how much she helped me over the few years I lived there.

My mom was also a lifeline. She knew how hard I was working. She came to visit one time and took me to Sam's Club to stock my pantry. I understood the large jar of salsa and the huge container of peanut butter, but I was never sure why we bought the industrial-size mustard. It lasted the entire time I lived out there. She also slipped me a gas card and gave me permission to fill up my tank twice a month. That was huge for me. I have no idea if my dad knew she did this, but I was so appreciative to have that kind of help.

I worked at a bridal shop Tuesday through Saturday. I took a job as a secret shopper, writing reviews for a local best-of ratings magazine, and I also worked Monday evenings, Thursday evenings, some Saturdays, and most Sundays as a relief care worker for a mom with ten foster kids. This job was through social services and it paid well. I loved those kids, and I learned so much being in that home. I saw Michael on Saturdays after work and occasionally during the week if there was a sports event I could attend. He couldn't leave campus without a pass, so we took advantage of any opportunity to spend time together.

Another plot twist came when I didn't get into the nursing program at the schools I applied to in Colorado. I got accepted at a school in Tennessee and one in Massachusetts, close to Michael's mom and dad. I didn't want to go back to Tennessee, so I accepted a spot in the school in Massachusetts and went to live with Michael's parents. This was an-other lifeline that came at the perfect time. Michael had proposed earlier that year, and getting through school was necessary so that we could get married and I could move with him to his military assignment. His parents took great care of me. His mom is a fabulous cook, and I loved having hot meals prepared that I didn't have to figure out how to afford. I probably ate them out of house and home. I know I ran up their phone bill, and I probably never let them know just how much I appreciated all that they did for me.

Michael graduated from the academy at the end of May, I graduated in mid-June, and we were scheduled to be married on July 1. One day Michael saw an unopened credit card bill on my dresser from the store Express. He said, "What is this?"

I told him, "I don't know. Open it." He did, and what he found did not make him happy.

It was a bill for forty-two dollars with an overdue late charge of twenty dollars. It was well over sixty days past due, and the fact that I hadn't even opened it blew his mind. He said, "We are not going to do this once we're married. You need to pay this off before we get married in a week."

I looked at him like he had six heads. I said as confidently as I've ever said anything in my life, "Well, you can either marry me with sixty-two dollars of debt or you can pay it off, but I don't have sixty-two dollars to pay that bill or I would have already taken care of it."

Needless to say, he paid the debt and we got married a week later. I was twenty-one and he was twenty-three.

I never gave that bill another thought until we applied for our first mortgage and the bank ran our credit reports. Of course, Michael's came up perfect and mine showed that sixty-day late charge. He glared at me as if to say, "See why it's important to pay our bills on time?"

That was about a year into our marriage. We bought a cute little story and a half in Dayton, Ohio. I agreed to live in Dayton for three years until the Air Force transferred us. Michael decided to take a transfer on base while working on his MBA, so I assumed it would be another year or two and then surely we would move south to start our family. Well, you know what they say about assumptions.

Three years turned into five, and now twenty-five years later, we still live in the Dayton area. Between our church family, the community, and our kids' school district, it has never made sense to leave. It's been our happy medium between my southern roots and Michael's New England heritage. We have loved raising our family in Ohio.

I'm telling you this story before we get to the nitty-gritty of showing up because it looks different for everyone. It has to. I could have pursued the version of success I was told to as a young woman. But that

wasn't me. That's a good way to get disillusioned really quickly. I don't blame anyone for giving up when it's somebody else's dream they're giving up on.

Comparing versions of success brings us back to the misplaced fear of it. Nobody wants to make big changes, invest time and effort, and have it all be for nothing. I pushed through fear because I knew the person I wanted to be—and the person I wanted to be with—were on the other side.

So that's where our journey begins together—redefining what success looks like for you. We're going to say goodbye to all the goals other people want you to achieve so you can unlock your true desires, find the path toward your future, and start showing up.

Ready to get moving?

CHAPTER 3

Goal - Setting Secrets of High Achievers

But be doers of the word, and not hearers only, deceiving yourselves.

—James 1:22 (ESV)

Where I grew up in the South, farmers markets and county fairs are social gatherings not to be missed. As an entrepreneurial-minded child, I was always amazed at the various offerings. How many pies does that lady have to sell to make it worth her time? Does anyone actually buy the ShamWow cleaning system?

At a little farmers market in the town where I live today, there's a friendly old man who sells handcrafted knickknacks made from walnuts. He makes everything from Christmas ornaments and sports souvenirs to figurines and picture frames. All out of walnuts. The thing is, I don't know if the guy ever sells any of them. As talented as he is, I can't say I've ever bought anything from him. One Sunday when we strolled past his booth, I saw an Ohio State University Brutus mascot doll with a walnut for a head instead of a buckeye. What are you supposed to do with that?

Walnut Man doesn't sell his nutty home decor hand over fist. Even if he does make an income, I doubt he's buying a yacht with that pocket

money. But I'll tell you one thing about Walnut Man—he seems so happy. He's always got a positive attitude. He looks cheery. Fulfilled. Like he's living his dream just by showing up at that market. I wish everyone could be as happy as him.

Walnut Man makes me think about success and our never-ending pursuit of it. How many of us feel disgruntled with where we're at? We look at the success other women have achieved and wonder why we don't have it for ourselves. In fact, you probably picked up this book because you thought it might make you more successful. But whose definition of success are you trying to achieve? If Walnut Man's version of success is having a six-figure side hustle selling walnut trinkets, he would probably be a failure. But if success to him is getting out of the house, meeting new people, and earning enough pocket change to take the grandkids out for ice cream, he's made it.

I've had the honor of training and coaching thousands of women. Not a day goes by that I don't catch a few of them getting caught in the trap of comparison and feeling like a failure. After all, 92 percent of people never achieve their goals.[2] Why?

Many women confuse inspiration with action. We listen to motivational podcasts and TED Talks, and we ask girlfriends to hold us accountable. But the biggest practical reason that most women fail to hit their goals is because they're not clear on what they want to achieve. We look around, and the next thing we know, we're trying to achieve someone else's goal. Sound familiar? When was the last time you saw a friend post on social media about an achievement and you felt you should accomplish the same thing? Whether it was last week, yesterday, or today at lunch, I'm going to help you choose your *own* goals—which too many women don't know how to do. In the pages ahead, we're going to make sure that the hard work you're doing is taking you in the right direction for *you.* Then we'll set you up to make progress toward

2 Marcel Schwantes, "Science Says 92 Percent of People Don't Achieve Their Goals. Here's How the Other 8 Percent Do," Inc.com, July 26, 2016, www.inc.com/marcel-schwantes/science-says-92-percent-of-people-dont-achieve-goals-heres-how-the-other-8-perce.html.

your goal, one milestone at a time. After all, life happens one day at a time. Shouldn't achievement be the same?

In this chapter, I'll be asking you a lot of questions. You'll be asking yourself a lot, too. Grab a pen and a notebook, or open a blank document on your laptop. Get ready to answer some tough questions and to write out your answers. Did you know that writing something down will help get you closer to your goal?

Let's do it.

THE SURPRISING ADDICTION THAT'S KEEPING YOU STUCK

First things first.

So, you've got a goal. Probably several. Lose weight, earn more money, be happy, figure out how to make those cookies calorie-free. It's what all women want, right? Now, it's likely that your current goals *do not* accurately reflect your heart's desire. What you *think* your heart desires may just be someone else's goals from the inspirational content you've been consuming. We're going to change that shortly. Right now, you deserve to know how you got into this goal achievement rut. How come no matter what you try, success seems further away than when you started?

Remember what my mentor once told me? She said I was good at putting off the hard things. I said I wanted solutions, but I was looking for a quick fix. I wanted a rush of dopamine to feel better about myself. I loved to talk about goal-setting and achievement, but there I was, wasting time on social media, scrolling, clicking, liking, commenting, subscribing, and buying. Nothing to move me along. At least I felt inspired—for the moment, that is.

That's the problem with inspiration. Needing that biochemical boost to get your butt in gear can turn into an addiction. I know that's a strong

word, and I don't use it lightly. I can say from experience that most women have an inspiration addiction. We seek inspiration but without taking action. Here's why that's so dangerous.

When you scroll social media to get motivated, the same thing happens in your brain as when a young man looks at pornography. That's a little horrifying, isn't it? When a teenage boy looks at airbrushed and photoshopped pictures of naked women, dopamine surges through his developing brain.[3] It's a feeling so good he has to have it again. Never mind that he's destroying his healthy view of women. And that's not the only damage done. According to a Cambridge University neuropsychiatrist, scans of pornography addicts' brains reveal *permanent* alteration to the brain's reward center.[4] That's the same thing that happens to drug addicts. And it's the same thing that happens when you follow one inspirational Instagram account after another. It's the same addiction to that dopamine high.[5]

On average, we spend two and a quarter hours on social media every day.[6] Can you imagine how warped a person's view of sexuality would become after watching that much internet porn every day? That's what will happen to your view of goal achievement. Internet porn and inspirational content both briefly satisfy innate needs that God wants us to fulfill in healthy ways. Why do men look at pornography? More often than not, they have a need for a fulfilling relationship. The real solution is for the man to get up off the couch, better himself, become a desirable

3 Todd Love, Christian Laier, Matthias Brand, Linda Hatch, and Raju Hajela. "Neuroscience of Internet Pornography Addiction: A Review and Update." *Behavioral Sciences* 5, no. 3 (2015): pp. 388-433, www.doi.org/10.3390/bs5030388.

4 Norman Doidge, "Brain Scans of Porn Addicts: What's Wrong with This Picture?" *The Guardian*, September 26, 2013. www.theguardian.com/commentisfree/2013/sep/26/brain-scans-porn-addicts-sexual-tastes.

5 Stephen Hartley et al., "Dopamine, Smartphones & You: A Battle for Your Time," Science in the News, February 27, 2019. www.sitn.hms.harvard.edu/flash/2018/dopamine-smartphones-battle-time.

6 J. Clement, "Daily Social Media Usage Worldwide," Statista, February 26, 2020. www.statista.com/statistics/433871/daily-social-media-usage-worldwide.

mate, and go out to meet eligible ladies. But that's a lot more difficult than going to a porn site, isn't it? Which explains why so many young men stay at home surfing the dark corners of the internet.

It's not the social media platforms themselves that are the problem. Just like having a sex drive isn't sinful. It's how you choose to use it that makes all the difference. Just as images of naked women don't fulfill a desire for physical intimacy, consuming inspirational content online won't help you make progress toward your goal. And the longer you use it, the harsher its effects.

With pornography, people become numb to the mild stuff and soon need more extreme content. The same thing happens with inspiration. At first, a Bible verse inspires you to work hard on your goal. Then you need a few quotes from your favorite authors' accounts. A week later, you need to watch a TED Talk. Soon you're an inspiration junkie, buying a year's supply of planners, a twelve-week goal visualization course, and VIP tickets to Rachel Hollis. In real life, you're going nowhere. You descend deeper and deeper into a fake world and wonder why you don't feel like getting out of bed. I know. I thought all those things would inspire me to greatness, too. I get it—I've bought the courses, gone to the conferences, and marked my planner with perfect coordinating highlighters. None of these things are bad if you take the inspiration and put it into action. It's not enough to just take it in. You have to apply it to move toward the right outcome.

What does the Bible have to say about this? Remember the verse you read at the beginning of this chapter? Be a doer, not just a hearer. Social media allows us to be the best hearers this world has ever seen. But not much doing gets done in the comments section. As for dopamine addiction, 1 John 2:16 (ESV) says, "For all that is in the world, the lust of the flesh, and the lust of the eyes, and the pride of life, is not of the Father, but is of the world." This lust refers to longing desires to possess or enjoy. Not necessarily to sin. Think about that. Lust in other Scriptures can refer to sinful desires, but John was writing about worldly indulgence in pleasure for its own sake. Sounds a lot like those two-plus hours we spend on social media every day, doesn't it?

Am I saying social media is a sin? Not at all—I use social media. But I *am* saying it can be addictive. An obsession with constantly feeling inspired doesn't move you any closer to what you want. And if you're serious about what you want, dopamine is an addiction you can't afford to have.

Breaking the inspiration addiction is the same as breaking any addiction. I teach my sons to protect their eyes and ears. If they stumble on something they know they shouldn't see, they don't linger on it. Because what your eyes see and ears hear tells your brain what to think about. And what you tell your brain to think about is what your heart eventually desires. Does your heart desire inspiration or action?

I had to ask myself this question a few years ago. I used to love to read *People* magazine. What a waste of four dollars. And the time I took to read it. I realized that I don't want to put anything into my subconscious that I don't want to spend time thinking about—whether that's from a magazine or elsewhere. I also used to be addicted to a news app on my smartphone. I spent so much time reading useless articles that shaped a negative and inaccurate view of the world. So I deleted it. It was that simple.

Let's apply this to our content consumption habits in all areas of life. Do we need to cut back on television? Unsubscribe from streaming services? Unfollow certain social media accounts? You need to filter what you allow to inspire you. We have to be disciplined about what we allow into our eyes and ears because it ultimately determines the way you live your life. What would you be dreaming about if you didn't have Instagram, Netflix, or *People* magazine? Would your goals be different from what they are now?

Technology is not the enemy, but what you're allowing yourself to consume can be. You need to apply a filter to what you're letting in. When you do get on social media, look for action-oriented accounts to follow that point you in the right direction. Don't scan a thousand accounts for inspiration. Follow helpful people whose content includes parenting tips, family dinner ideas, easy recipes, or exercise routines. Follow accounts that add value to what you're working toward. Then make a commitment to yourself that when you see something that in-

spires you, you do something about it. It's the difference between doing the exercise that slims your waistline and just saving the meme for later. Liking, commenting, and feeling good in the moment won't help you get in shape.

You *can* use social media without feeding a dopamine addiction. But even if you use it in a healthy way, it can still be beneficial to have a social media detox from time to time. It can suck away your time more than you might realize. Which brings me to my next questions.

WHAT DO YOU REALLY WANT?

As you define your heart's desire—possibly for the first time in your adult life—think honestly about what it is that you want. Being honest with yourself also means being realistic about what you can and cannot accomplish. Do you *really* want what you say you want? If I say I want to tone up and get in shape while I'm eating M&Ms, that's not an honest goal. There's a difference between looking at a dream, saying it's nice, and working for it. Your goal doesn't have to be extreme. You don't have to build an orphanage in Haiti. It could be gathering around the table for three family dinners a week.

Once you know what you want, you can build your own personal inspiration ecosystem with reminders of your goal. What you let inspire you *must* be focused only on those things you want to achieve. In this chapter, I'll teach you the life-happens-proof goal-setting system I use with my team members.

WHERE DO YOU SPEND YOUR TIME?

Now that you know what you really, truly want, look to see how you are spending your time. What do you need to change in your current schedule to make time for the things you really want?

When I coach people, I always start with a calendar audit. I often find that women are filling their time with either learning something or

creating lists. They keep themselves busy and say, "As soon as my office is organized, I can send those messages." Or, "As soon as I'm done with this course, I'll be able to get my life together." They spend more time getting ready to do things than doing them. They're entertained watching how-to videos, but they're getting nowhere. I'm not saying you should never learn something new or make a to-do list. But don't use it as a fancy way of putting off something you need to get done.

THE PROBLEM WITH ACCOUNTABILITY

You've probably heard of accountability partners. Maybe you've asked a girlfriend to hold you accountable for going to Pilates every week. It was her job to be your own motivational speaker, inspiring you to keep going when you felt like throwing in the towel. There's just one problem—accountability partnerships fail nine times out of ten. When you talk about what you want, your brain thinks you've already made progress toward it. Your drive to succeed collapses because your body confuses talking about your goal with achieving it.

I still hear people saying they want somebody to hold them accountable. I'm very much the opposite. I'm a private person, which often surprises people. I don't share my goals with anybody until I'm right about to tip the scale and make them happen. While I'm working on achieving a goal, even my best girlfriend may not know about it.

Have you considered God as an accountability partner? How's your prayer life? Matthew 6:5–6 (ESV) says, "And when you pray, you must not be like the hypocrites. For they love to stand and pray in the synagogues and at the street corners, that they may be seen by others. Truly, I say to you, they have received their reward. But when you pray, go into your room and shut the door and pray to your Father who is in secret. And your Father who sees in secret will reward you."

Broadcasting your goals without working toward them is a lot like praying in public to get noticed. It's not going to help you achieve them.

Prayer is a lot like goal-setting. In prayer, you're aligning your desires with the heart of God. If you're out to achieve a goal, you need to be aligning your actions with what you want. *You* have to be an honest critic of your own work. An accountability partner can't tell you if you're doing everything you can to accomplish your goal. You shouldn't pray to elicit positive feedback, and the same goes for broadcasting your goal and your progress toward it.

Instead, what I do recommend are trusted advisers who you can pray with and bounce ideas off in private. *Private*. Not on social media. I have a group of ladies I pray with online every Wednesday—Holly in Chicago, Stephanie in Georgia, Cindy in Tennessee, and JoDee in South Carolina. We share what's going on in our lives, what we need prayer for, and what we're excited about. Everything is just between us. It's not boastful. Many people feel the urge to shout their news from the rooftop. I encourage you to share in private. Work in private. And hold *yourself* accountable. Don't expect the world to do it for you.

WHAT DO YOU NEED?

If you don't have a close support group right now, it's time to ask for one. I know, it's harder than it sounds. I'm not great at telling people what I need either. There was a time in my life when I thought that my husband should always just know what I needed. I didn't think I should have to tell him. It seemed pretty obvious to me that I needed help. I mean, for goodness sakes, the house was a disaster, and there was no telling when my child had their last bath. What exactly did he need me to say? I'd tell Michael I needed help, and he would do something that he thought was useful, like organize his sock drawer. OK, not really, but he would clean the kitchen sink to a spotless shine but not even notice the Legos and trains all over the floor. Then I'd still get upset because it wasn't what I needed. And I just expected him to know.

People aren't mind-readers. Don't be afraid to have some honest conversations with your partner and the people closest to you to make

sure that you're all getting what you need in this season of life. You can't assume that people know what you need. Chances are they don't, or they'll assume you need something different from what you really need. Express what you need. Don't get bitter and angry because you expect your spouse to read your mind like I did.

It's OK to ask for support. Just don't confuse feedback with motivation. Only a goal aligned with your heart's desires will motivate you to stick with it long enough to see it through. What your trusted advisers *can* do is help you talk through what you want, what you've done to get it, what results you've seen, and what you can do to adjust. My personal trainer once told me that you can't out-exercise your fork. If I'm not willing to eat better, working out at the gym five days a week will only trim ounces, not pounds. It's easy to say I want to look like a runway model. Even easier to like their photos on social media. But how bad do I want it? Do I even know what it takes? If I don't, how can I decide if it's worth working toward? Knowing what it takes to get what you want allows you to determine whether you really want it and are willing to work for it.

Personal commitment to change is the only way forward. That doesn't come from reading inspirational quotes or telling accountability partners your goals. You don't have to put your desires out into the universe or "name it and claim it," as the local churches I knew growing up in Tennessee put it. You have to commit to what you want, find out what that commitment requires of you, and meet those requirements. Every day.

WHY MOST GOALS DON'T WORK (AND WHAT TO DO ABOUT IT)

As you now know, most goals you thought you had before reading this book probably weren't yours. They ended up in your head and in your heart from hearing and seeing others talking about them. It's no wonder you haven't been able to work very hard to achieve them. When

you make someone else's goal your own, it's like wearing a fancy pair of shoes to a 5K you don't want to run. You quickly realize you are unprepared and soon feel miserable trying to keep up with the crowd.

I see this a lot in direct sales. Someone is making $400 a month on the side. They are thrilled with this slush fund. Then they see a lady making $4,000. They immediately feel like a failure compared to her. But why? Why would you want to borrow someone else's definition of success and let it steal your joy? I often ask my team what they hoped for when they started their networking marketing businesses. Some say they just wanted to be able to pay for travel soccer. Some say they're just thrilled that their daughter can do an elite dance competition without them having to scrape together loose change to make it happen. That's when I remind them that if they've done exactly what they've set out to do, they're the literal definition of success.

What if their heart's desire changes? Maybe they used to be content with a little extra cash, but now they want to save for a new house. That means it's time to get clear on what that new goal requires of them. I always ask aspiring entrepreneurs what hours they would be available to work if they had to apply for a job. Most of the people I talk to are stay-at-home moms or part-time professionals, so usually they have fairly restricted hours. Still, I get them to write down every fifteen-minute interval that they're available throughout the day. Maybe if the kids get up at seven, they're willing to start work at six. Small chunks of time add up. When I was first building both of my businesses, my kids went to bed at eight thirty. I clocked back in then and worked until two in the morning. I knew what I wanted, and I was willing to pay the price. If that sounds like an awful life to you, what does that tell you? *My goals are not your goals.* They don't have to be. Decide for yourself what it is you want.

This is also true for corporate jobs. When women say they want what another woman has, but they're not willing to travel, have evening meetings, do spreadsheets on the weekend, and respond to emails after

hours, they're going to be disappointed. You can want what someone else has, but if you're not willing to work the way she works, you're not being fair to yourself. Look at yesterday. Think about that day from the moment you opened your eyes to the second your head hit the pillow again. If you repeated that day for the next thirty days, would you be any closer to living the life you want? If not, what would you do differently?

No one is perfect. It's easy to say what we think society wants to hear. I'm a hardworking, respectable human being who people listen to. I should have better eating habits and exercise daily. But until I decide that I want that, it's not going to happen. I do a weekly evaluation on Sunday evenings. I use my Workflow Worksheet to plan my week and set my priorities. As I look at my self-care and nutrition, I decide I should give up sugar starting on Monday. Almost every week I make this proclamation: No more sugar starting Monday morning. Most Mondays I make it until about noon before I decide a little sugar is good for me. I even go so far as to tell myself that maybe I'm the fortunate one— my body uses sugar differently. Like I have some alien metabolism for sugar! Turns out I don't, and sugar is no more my friend than it is yours. So, do I want to change my eating habits? I must not because I'm not willing to work at them.

To say you want to be a size two may not be realistic, but to say that you want to lose ten pounds is. You can set an honest goal of exercising a little more each day. It sounds small, but if you can accomplish that minor win, you're more likely to be motivated to set the next obtainable goal. If you're always setting a goal that you're not going to work for, it's a self-fulfilling prophecy of deceit and failure.

Put down your phone, stop your scroll, and be honest with yourself. Grab your pen. What do you want? What are you willing to do to get it? Being honest with yourself about what you are willing to work for *will* make you happier. You're much more content when you're working toward something that you're capable of accomplishing.

MY LIFE-HAPPENS-PROOF SYSTEM TO ACHIEVE ANY GOAL

Now you know that what you see and hear tells your mind what to think about, which tells your heart what to desire. Start with what you want and work backward. If you know you want your kids to eat more vegetables, you should be consuming content with recipes for making veggies more appetizing. If you know you want to earn a promotion, you should be consuming content that improves your confidence and educates you on the position you want. See? When we start with what we want and work backward, we can see what we should listen to and look at.

Fast-forward to a year from now. What do you want in a year? What *don't* you want? What are you going to keep doing, start doing, and stop doing to make it happen? Once you have a vision for what you want your future to look like a year from now, you'll see what you need to add to your life and what you need to eliminate.

Now it's time to write down your big goal. *What do I want?*

Big goal: I want _____.

Once you have your big goal, think about what results you need to achieve to get you there. Make them specific, measurable, and even numeric. These should not only be tasks you need to achieve but also actions that bring you closer to your goal.

Then begin to build a plan of action. In business we call this your objectives and key results. OKRs for short. Basically, how can you tell when your goal is achieved? What are the specific results that prove you were successful? What are your objectives along the way? What tasks *must* get done to move you closer?

Here's an example.

Big goal: I want to replace my income from my part-time job so I can stay home with my children by the end of the year.

Key Results
- Earn $1,000 per month.
- Pay off car loan, $3,000.
- Pay off credit card debt, $1,200.
- Cut extra spending by $300/month.

Objectives
- Evaluate work-from-home options and choose the most promising offering.
- Discuss with current boss the opportunity to freelance from home.
- Make additional $300 payment on car loan for ten months.
- Decrease investment allocations by $600 for two months to pay off credit card debt.
- Eliminate eating out for lunch and daily Starbucks by packing lunch and making coffee at home.
- Postpone family vacation until the following summer.

Here's another example.

Big goal: I want to improve my self-confidence and begin public speaking.

Key Results
- Write your speech and practice it with family or friends.
- Apply and accept two speaking opportunities in the next six months.

- Read one book on public speaking each month.
- Attend Toastmasters meeting two times per month.

Objectives
- Research top books on public speaking.
- Pick my first book to read.
- Join Toastmasters.
- Research speaking opportunities in my areas of expertise.
- Schedule dedicated time to work on speech, rehearse, and practice.

Now it's your turn. Write down any key results and objectives that will help you achieve your goal.

DOUBLE-CHECK: IS THIS GOAL RIGHT FOR YOU?

When I work with a new coaching client, we start with what they're hoping to accomplish. Then come the hard questions. What's holding you back? What are you afraid of? What are your what-ifs? For example, what if I don't have enough time to take on this project? Or, what if people think I'm dumb for spending my time this way? These are based in fear. How do you change what-if to what-is?

What-is statements are based in truth. What *is* true about you in this circumstance? For example, what time do you have to devote to this project? Or how can you use your time better? What level of expertise do you already have on this topic? What can you do to become more competent in this area? What kind of reputation do you have? How can you accomplish this goal without jeopardizing that reputation? Or, are you OK with people having opinions that don't align with your true intentions?

What if this goes terribly wrong? What's the worst-case scenario? What if this goes amazingly well? What's the best-case scenario? And I

mean home-run-out-of-the park-big-totally-awesome best-case scenario! That list wasn't just for you to read. Ask yourself those questions and answer them with pen to paper.

Next, create a pros and cons list. Split the page in half, draw a line, and write those pros down. Now the cons list. Identify any true risks, like loss of income. Cross out any false risks, like worrying that people will think you're crazy. Now, weigh the pros against the cons. Based on this list, do you feel comfortable moving forward?

What other questions are coming to mind about your goal? Let's get them out and answer them right now. Are you willing to take the next step? What *is* that next step? Go back to your OKRs. What needs to happen first? Your only focus should be on your next step. Once you tackle that, you can reevaluate and determine whether you're ready to keep moving forward. Ask yourself:

- Am I content or complacent? (They walk a fine line together.)

- Am I being honest with my goal? Do I want it, or does it just sound good to talk about it?

- What negative self-talk has been controlling me?

- Am I being an honest critic of my work and time spent?

Don't be afraid of a do-over. If you've completed the double-check and you've seen that this goal is not for you, go back right now and set a new one.

Pursuing someone else's goal is more common than you might think. Trust your instincts over your Instagram. It doesn't matter what outside source you're looking to, really. Just because a close friend or someone you respect is achieving something or about to achieve it doesn't mean you should, too. If you're letting a hundred different people inspire your goal-setting, you're going to have a hundred different goals. Throwing yourself in every direction will keep you from being able to make the right decisions that move you closer to the few goals you ought to have. Yes, seek wise counsel. Feedback can be useful. After that, though, you have to make the decision—set and pursue the goal—that's right for you.

Even if you go against wise counsel. Only you can make the decision for yourself. If you believe a goal is right for you, you have to pursue it no matter what the survey results say. Then you can evaluate whether it was the right goal. If so, keep going. If not, learn something from it and set a different goal, one even more aligned with your priorities.

HOW TO MAKE PROGRESS TOWARD YOUR GOAL

Achievement doesn't happen when *you* aren't happening. Here's how to move toward what your heart wants.

SACRIFICE

Once you've aligned your heart and your desire (your big goal), it's time to set a fast pace. That may seem easier said than done, and you might wonder if it's necessary. But it's the same amount of work spread over a different amount of time. Why take seven years to do what you could do in three? To maintain a fast pace, you'll have to make some sacrifices. I'm not suggesting you abandon your family, but you might not go to every Little League game. Or if you are at every game, you may start sleeping six hours a night instead of seven. Whatever is important to you, schedule around it and make sacrifices in areas that are less important. Do you have to give up everything? No. If you work smart and make the sacrifices that make sense, you'll have so much to show for it.

The only television I watched during the first three years I was building my direct sales business was one hour on Sunday nights. People think I'm joking when I say this, but it's true—I didn't watch TV, I worked on my business. That was a sacrifice worth making. Did I miss some of my kids' events? Yes, I did. Thankfully, they aren't any worse

for the wear. I made sure I was at all the important stuff. Going to the book fair, baking cookies for the bake sale, and never missing a game doesn't make you the perfect mom. When I'm at my kids' events, I'm fully engaged. I'm not thinking about work or worrying about life. And when I can't be there, they understand because I've taught them the value of hard work by setting the example.

It's easy to get discouraged when thinking about making sacrifices. I wish I could tell you that big goals could be accomplished in big leaps, but that just isn't so. Giant journeys require lots of small steps. Stop focusing solely on your big goal and focus on the individual steps that will get you there. Focus on what you can do right now. True fulfillment is taking action and accomplishing something. A little bit of action is better than being perfect. Even a sloppy step in the right direction shows tangible progress.

BE REALISTIC

If you set lofty, unachievable goals, you're setting yourself up to fail. When I first started in network marketing, they told us to send two hundred messages in the first thirty days. I didn't do that. Then I started wondering why I was coaching people to do that when I hadn't done it myself. One of my business partners had sent two hundred messages in her first month, and it had worked out well for her. I sent two per day, Monday through Friday. Ten per week was a bite-size goal that led to great success for me. It was achievable. Fifty per week was not. Can you see how it's different for everyone and that finding what's right for you will help you work for what you want?

Achieving your goal will be made up of many steps. Today's step might be a little bit bigger than yesterday's, and tomorrow's might be a little smaller. That's OK. Any step forward is progress. Even if you don't meet all your objectives this week, that doesn't mean you set a bad goal. It just means you have to prioritize differently. You have to realign with your goal.

Instead of trying to achieve a big lofty goal, choose one hard thing to commit to doing this week. Rather than saying, "I'm going to give up social media," what if you set a limit for yourself and stick to it? Maybe fifteen minutes of enjoying your social media just before the kids get off the bus. Maybe you can take steps to clean up your feed. When you see something that makes you feel negative or unworthy, you can unfollow that person. Find a better solution than all or nothing. Something is always better than nothing. Don't get hung up on doing nothing when you're afraid you can't do it all.

LIVE YOUR DREAM

That brings me back to Walnut Man. As far as I can tell, he's living his dream. *His* dream. Whatever yours is, I want you to go after it like crazy. Maybe it's having your own arts and crafts booth at the weekend market. Maybe it's starting a side business you can work on after you put the kids to bed. Maybe it's more time spent studying God's word. Maybe it's getting yourself into shape so you can fit into your high school jeans again. Whatever it is, if you work the plan, the plan will work. Because your time on this earth is precious and limited. Why not spend it doing what you feel called to do? Why not spend it doing something that *matters* to *you*?

CHAPTER 4

Embrace an Imbalanced Life (Because Time Management Is Not a Thing)

For each will have to bear his own load.

—*Galatians 6:5 (ESV)*

When I first met Michael, he was fascinated with southern slang. The first night we met, he even wrote down a few key phrases. "Bless your heart" was probably the funniest one to him. "So you can add 'bless your heart' to the end of an insult and it makes it OK?" Hmmm, I never thought of it that way, but yes. There are a lot of nuances to the southern way of communicating, and if you didn't grow up there, I guess it can seem kind of crazy and hard to understand. We don't always say exactly what we're thinking, but if you pay attention to the slang and some solid body language, we get our point across. In this chapter, I'm going to lay southern social graces aside and shoot it straight, sister. Buckle up, here we go!

Bless her heart, she's trying to get *everything* done.

Women want balance. In doing my research for this book, I found out that over 450,000 people google ways to live a more balanced life

every month. That's almost 5.5 million a year. Crazy. Understandable. And sad.

We think we want balance. We want to get everything done—housework, homework, yard work, side hustle work, you name it. We tell ourselves we want it all because we deserve it all. But here's the cold, hard truth: balance doesn't exist.

Nope. Balance ain't a real thing. If you're like the other half a million people who are so hung up on being balanced that you're consulting Dr. Google, guess what? It's time to make a radical change to the way you think about your life. Let's consult the classic dictionary definitions so you see what I'm getting at.

balance (*verb*): to have equality or equivalence; to be in equilibrium

If you want to achieve the goal you set in the last chapter, you're going to have to work for it. People who sacrifice for what they want look very out of balance. If you want to be a goal-achiever, whatever your goal may be, while also taking care of your family, something has to give. Embrace that imbalance.

And while I'm on this real-talk rant, I'll tell you something else. There's no such thing as time management either. Am I saying you should waste your time? That you shouldn't be mindful of what you spend your life doing? Of course not. What *am* I saying? Let's consult the dictionary once again.

time management (*noun*): the analysis of how hours are spent and tasks are prioritized to maximize productivity

Sounds like a good idea, doesn't it? Analyzing, prioritizing, maximizing? I'll tell you why it doesn't work for your life. When we ladies *talk* about time management, we're talking about the *what*. All those smart *-zing* words from the dictionary definition are great, but when we try to put it into practice, time management strategies descend our lives into burnout and downright chaos.

Too many women I've met in business, church, and life in general spend all their time "managing" it. When they're done, there's little time left to do anything to get them where they want to be. You can't divide your schedule into all these neat, clean, perfect little categories, deciding what has to be done and what doesn't. Real life doesn't work that way. Reorganizing your schedule doesn't get you out of doing the hard stuff. You can make lists until your fingers cramp, but eventually you have to tackle the list. I always tell my team that if you want to succeed, you have to *do the work*.

Did I just make you want to throw this book across the room? Hang with me till the end of this chapter. If you still think I have absolutely lost my mind, then be my guest—chuck this book into the garbage. Give me until then to shed some light on a few things and give you hope.

If you're going to have a shot at achieving the goal you set for yourself in the last chapter, then we have to get serious about what is and isn't possible. For most of us as career women, wives, mothers, and possibly wannabe entrepreneurs, we can't schedule everything. No amount of time management skills can manage a schedule with too little time for the important stuff.

That, I believe, is the real myth about balance. You can't have it because you have only so much time. There's a reason Michael and I quit watching TV and skipped sleep as we built our businesses. We rejected the whole notion of balance. We could either work late or not pay our bills. We could keep struggling financially or figure out a way to make work a priority while raising small children. But it was this life of complete imbalance that we credit for being able to live the financially free life we do today. You might say we believed we didn't *deserve* balance if we wanted our dreams to come true. I know that's not a very inspirational message. Well, I didn't feel inspired working until 2:00 a.m. many nights for five years, but I did feel accomplished.

There *is* a solution to getting all the important stuff done, but time management in the usual sense isn't it. This so-called state of living in balance cannot be achieved. What I offer you in place of that impossible goal are these beautiful little tools I call boundaries.

THE LOST ART OF FIRM BOUNDARIES

Before I understood boundaries, I was barely keeping up. In fact, I was falling behind. As a pharmaceutical sales rep and first-time momma, I had the best of the two worlds all women are supposed to want—a job to excel at and a young family to love. But I found myself torn in half most days, something nobody told me to expect.

Our first child, sweet Camden, was experiencing health concerns. Michael and I had gotten accustomed to my lucrative salary and great perks like the free car that came with my job. Quitting to stay home full-time didn't seem feasible. And I wasn't sure I wanted to do that anyway.

On one particular day, I had an important meeting scheduled. On the way to drop Camden off at the babysitter's, I noticed his asthma cough getting worse and worse. It seemed OK until it didn't.

"Camden, just hang in there until I get through my meeting. If you still feel bad, Momma will come back to get you," I told my toddler.

As I pulled up to the sitter's, I glanced in the rearview mirror and saw that his little lips were blue. He was struggling to breathe. I'm embarrassed to admit my next thought. *Surely he'll be OK until I can get through this meeting. Then I'll take him to the doctor.* Thankfully, my conscience gave me a serious priority check. I knew I had to take him *now*. I didn't even get him out of the car. I called the sitter and told her he wouldn't be there that day. I drove us to the doctor. Camden's breathing didn't improve on the way. I still expected it to get better and I would go to work. It didn't get better; it got worse. We left the doctor's office with an inhaler, two oral prescriptions, four to six breathing treatments a day, and a completely overwhelmed momma bear. How was I going to do it all? I called my boss, quit my job, and cried.

I cried because my son was sick. I cried because I almost sacrificed my child for a job that would replace me in a hot second. I cried because I didn't want to give up a job that I loved. And I cried because I wasn't sure I could be a stay-at-home mom.

When Michael and I got married, I told him I had five good years in me to work full-time and help build our finances. After that, the plan was to start a family and stay home with our children. Society told me I should want to be a stay-at-home mom, so that's what I wanted to be.

Until I was one. Realizing I was terrible at the most important "job" any woman could ever have was tough to swallow. I loved working. Really loved it. I learned quickly (and I wish I could say unapologetically) that I was a better mom when I also had another job to use the gifts and talents that came more naturally to me than motherhood did. I love my kids. They're awesome. But in those early days, it was tough. If you're a stay-at-home momma, I see you. And I know it's not easy. If people tell you that you make it look easy, maybe it comes more naturally to you. But I've got an inkling that people are just looking at your highlight reel. You feel the same strain I have but you're ashamed to admit it. Either way, hang in there. You're doing better than you think. If you need something just for you, be honest with your partner. Talk about how you can add something to fill you up so you have a full cup to pour from. That's what I had to do. I knew I wanted to work, but I also wanted to be available for my family. How could I do both well?

I'd always dreamed of owning my own business but had no idea what that would look like. I tried my hand at several things before I was fortunate to get connected to my first business partner, a professional photographer. She had a great idea, and thankfully I had the skills to help execute it. We launched that business with a few dollars in our pockets, a lot of grit, two toddlers at my feet, and another kiddo on the way. Was it easy? No, it was awful in all the right ways. Was it worth it? Absolutely, and I would do it all over again. If you get creative and you're willing to make some changes, understanding there will be sacrifices, you *will* find your sweet spot. It won't always look pretty, but it will be so worth it.

I tell you all this not only for your sake but also for mine. To remind me why I need boundaries. How often we forget we need them. Without boundaries, you'll find yourself living for everyone else. Even if you

achieve your precious goals, you'll find yourself unable to enjoy them. I know because that was me. Several years into my entrepreneurial journey, I was a mess. I was working to grow my businesses, raising young children, trying to be, do, and have it all. It was impossible. I vividly remember a thirty-two-minute drive when I wondered what I could do to get out of my next three weeks of obligations. I had worked my butt off to build our businesses. All I ever wanted was to be my own boss, work on my terms, and build a life that allowed me to be in control of my calendar. And there I was, fully in charge of my schedule, but it was completely out of hand. I was overcommitted to all the wrong things, and I desperately needed to figure out a way to enjoy the very life I worked so hard to build.

How can I take myself out but not get hurt too badly? I thought. *What if I just ran my car off the road into the ditch?* I never had suicidal thoughts, and I don't want to downplay their serious nature. But I did brainstorm excuses that people would accept so I could back out of all the things I'd said yes to. I decided driving into the ditch wasn't it. I don't like pain. A broken leg would just mean showing up on crutches, and that seemed worse. Not to mention the obvious shoe dilemma.

As I approached a bridge, I considered veering head-on into the guardrail. No, that would total my car and add more problems to my schedule, not clear it. Can you imagine? From the outside in, you would've looked at me and thought I had everything I wanted. The truth is, I was doing everything everyone else thought I should be doing. It wasn't until I got committed to my real priorities, learned how to manage others' expectations, and stopped saying yes to all the wrong things that I got to enjoy the life I sacrificed so much to build.

The only way to get there is through boundaries—a boundary around everything you want guarding your time, attention, and sanity from that which you don't. Today I still live a busy life, but my firm boundaries keep me feeling happy and satisfied. Pay attention to what I didn't say. Balanced. Boundaries allow me to curate my life so I make sure I'm spending my time doing what I want to do. Before I instituted these

boundaries around my time, I let little tasks and unimportant to-dos clog my schedule. Boundaries are what taught me to say no.

Do I want to go for coffee with you? I probably do, but can I? No, I can't give away that hour because I need to spend it preparing for my next speaking engagement or working on what I have listed as my priorities for the week. I have boundaries.

Looking at scheduling this way may seem totally off-balance. But I know what I want and what I don't. By this point in the book—and in your life—you do, too. Why would you let little, unimportant things come up and take that away from you? Whether it's fun (gossipy) coffee dates with girlfriends or zone-outs in front of the TV before bed, you need firm boundaries to keep your time dedicated to things that move the needle toward your goal.

I know what you're thinking. *I need quality girlfriend time.* I agree. I do, too. The keyword is *quality*. Am I telling you to desert your friends and kill your social life? No. I've gotten good at telling people about my boundaries without hurting their feelings. Take some time to think about your boundaries now, before someone asks you to do something you don't have time for. Think about an alternative you could offer that wouldn't rupture your boundaries. This makes it easy to know what to say beforehand to enforce your boundaries without offending anyone.

For example, an acquaintance asked me to coffee last week. Let me be honest here. I'm never going to have coffee with her. That's just not something I'm going to do. I could just say to her, "I'm never going to go to coffee with you, ever," but that would hurt her feelings and make me a rude person, and remember, I'm southern. We don't say those sorta things. Instead, I said, "I appreciate you asking me, but unfortunately my calendar won't allow it. Why don't we grab a cup of coffee at home and schedule a time to chat on the phone." See? An alternative I can live with.

It turns out this lady had a pretty specific motive for asking me to coffee. She wanted to pick my brain about starting her own part-time direct sales business, something I knew I could help her with. Did I back down and agree to the coffee? Nope. I simply said, "I'm so glad you thought of me, and I'd love to help you. I can't fit in a coffee date right

now, but I do have a group coaching session that I'm leading next week. Would you like to be added to the group?"

Whenever someone asks something of me that crosses my boundaries, I look at how I could best help them. How can I plug them in without sacrificing my own sanity? Before I give them an answer, I come up with the best solution I can offer that works for both of us. Now, does that mean they'll be completely satisfied? Not usually. Often people want one-on-one time with me, as I'm sure they do with you, too. Let me be blunt. Your priorities are more important. Unfortunately, life has a pecking order. Some people are going to help you move in the direction you want in life. Those who aren't only take you away from it. Harsh, I know. And true.

Don't get me wrong, I love to volunteer or work with charities as much as the next person, so I include those in my priorities. You can give your time away, but just make sure you are giving it to activities you've established as important to you. That might be coffee with friends. It might not. It's different for all of us.

Let's come back to your goal. How badly do you want it? Are you willing to say no to people? Are you willing to establish your boundaries and reinforce them when someone pushes up against them? Remember, you can do this politely. You should always spend your time on what is going to get you where you want to go—not on how guilty you feel when someone asks you to spend it on them.

Did you notice I mentioned the *g* word? Ah, guilt. I would feel guilty if I didn't close that open loop (see what I did there?). People often ask me if I ever feel guilty for working so much. My reply is always, "No. Do you feel guilty for *not* working as much?" My voice is dead serious. There's always an awkward pause. Then I laugh. Most of the time they laugh, too. You could call it breaking the ice. I call it speaking the truth with humor and love. A little laughter goes a long way in life.

I work exactly the right amount for my family and for myself. What's right is different for everyone and often changes throughout the varying seasons of life. Instead of obeying guilt's command to give in to what other people want, why not recognize it for what it is and decide not to let guilt have the upper hand.

Here's what I mean. At my professional speaking engagements, I meet a lot of pastors' wives. Don't ask me why they end up running in my circles. I have no idea. But I'm always amazed at the number of them who come up to me after my talk to express their worries about how their calling into ministry affects their children. They're concerned about how much time they spend working at church and how much of that work follows them home. Michael and I both work from home, so our kids see us work all the time. But we're with and around our kids more than anybody who works a standard corporate America nine-to-five job. We drive them to school. We're home when they get home. We might still be working around them, but my kids will repeat back things they've heard me say on coaching calls, and they'll apply that advice to their own lives. I feel like we're the best role models possible for our kids.

I tell as much to every pastor's wife I speak to. Not too long ago, one of them said to me, "But, Jessica, my husband and I were called to this ministry. Our three kids were not."

"Girl, God isn't surprised that you and your husband have children," I told her. "God didn't call you and your husband, then leave you to figure out what to do with those three kiddos. If there's a calling on your life, then God wants you to bring your children into it. Allow them to grow to be a vital part of it, too. Your calling can only benefit them."

Now that we've dealt with guilt, let's get back to the real task at hand—setting and enforcing boundaries around your schedule so you only spend time working on things that matter to your future. For me and for the thousands of women I coach to build successful businesses, even while raising children, the secret is discipline. Your boundaries require it.

REAPING THE REWARDS THAT DISCIPLINE SOWS

A disciplined woman reaps what she sows. Discipline is not deprivation. When you set up boundaries in your life, what you're doing is

setting up a system to ward off time-wasters. And if you're not wasting your time on pointless social calls, mindless newsfeed scrolling, or TV show binge-watching, what are you doing? *You're getting things done.*

Discipline in any area of life is rewarding. Discipline to maintain your boundaries is the *opposite* of restrictive. It gives you the gift of clarity. If you hold yourself to an intentional level of accountability within your own preset guidelines, you are free to work on what is most important to you.

Anything we want in life is simple—happy kids, a fulfilling marriage, a great income, spiritual growth—but that doesn't mean it's easy. Daily discipline is the price you must pay. For example, in the direct sales business, you not only have to ban time-wasting activities but also force yourself to complete money-making activities—even when you don't feel like it. *Especially* when you don't feel like it.

Daily discipline in *any* business is a must. You can't be inconsistent and expect results. But you know what the good news is? It's never too late. I tell my team, if you're not holding events, start. If you're not talking to new potential team members, start. If you're not posting before-and-after pictures on social media of you or others using your products, start. If you're not looking for ways to expand your network, start. And if you're not messaging people and talking to people face-to-face or voice-to-voice, start. People are curious, but they often won't reach out themselves. They'll be flattered when you think of them. This applies to any industry. If you are a church planter, a recruiter, a financial planner, a PTO mom, or a Realtor. You all need to expand your network. Actually, everything I just listed works, even the before-and-after pictures. Show people what you're working on. When they need your services, they will think of you.

Got all that? OK, good. So, we've reset the way we think about balance. We've rejected the myth that we can do everything we would like to do in a single day. And we've learned that discipline is the secret to getting what we want in our work, our relationships, our marriage, our family, and our life overall.

You might call this the *what*. But the last thing I want is for you to

get excited about changing the way you spend your days, only to go back to letting other people schedule *their* priorities into your life. Let me show you the all-powerful *how* of boundary-setting and discipline.

MY SEVEN RULES TO SET BOUNDARIES, STAY DISCIPLINED, AND GET THINGS DONE

By this point, you're still a little on edge about this idea of building boundaries into your life. I get it. Even though you feel like boundaries will be worth it, you're wondering if they will be too confining. Let me tell you a quick story.

On Sunday afternoons as a teenager, I'd ride down to my friend Marie's farmhouse to watch movies. It seemed like every Sunday a neighbor would knock on the door and tell us that her brother Tony's cows were out. Tony was never home, so Marie and I would be out there under the baking sun herding cows back into the fence. Now, I was never afraid of those cows when they were inside the fence. Even if I was inside the fence. When they were within their boundaries, they felt safe and I felt safe. But outside the fence with me trying to prod them back into the safe zone, they felt chaotic.

See, that's the beauty of boundaries. They make you safe. They set you free. They allow you to be who you are. But when we don't have good boundaries, when we have a break in our fence, out go our goals and in comes the anxiety. When we decide what our boundaries will be and stick to them, we don't find ourselves confused, scared, guilty, or disappointed. So let's talk about that next, the sticking part.

Over the years, I've collected and followed seven general rules to get the important things in my life done. Think of these as your blueprints for setting your boundaries. Follow them like a construction contractor follows building plans, and you'll set up impassable

boundaries that all but guarantee you'll live the satisfying, disciplined, imbalanced life you desire.

DECIDE BEFORE YOU ARRIVE

Whether I'm headed to a speaking engagement, a party, a family dinner, a massage, or my kids' school to pick them up, I decide what outcome I want ahead of time. Do I want to inspire and encourage people? Do I want to make my children laugh? Do I want to show my husband how much I love him? When you take the time to think about what it would look like for things to go *exactly* the way you want them to, you transform your mindset, your energy, and in turn, the outcome of the situation itself.

Always decide how you want things to go before you arrive, and you'll be pleasantly surprised at how often they go your way. I also decide how long I'll stay. I build it into my plan, I make it known, and I stick to the plan. This helps me not give away more time than I have to dedicate to that particular activity.

KEEP A NO-CANCELLATION POLICY

Unless there's a life-or-death emergency, I never cancel anything on my calendar. Schedule *your* priorities. Do not place other people's calendars above your own. What are your true priorities? What things have you been allowing to take precedence over those priorities? How can you eliminate them to allow more time for the things that are important?

Once you have a clear understanding of what you should be doing, stick to it. Don't cancel on yourself, no matter what. I choose to do the hard things first to avoid a life of dread, and you can, too. This is important: If you get the hard things done first, you're going to enjoy your days so much more. Don't postpone or avoid them.

TIME BLOCK LIKE A CRAZY PERSON

Is it just me, or do we ladies expect ourselves to be able to do 101 tasks at one time? Handle phone calls, play with the kids, clean the house, respond to text messages, check email . . . and that's all while making breakfast. Don't get me started on dinner!

If we want to get more done in the precious little time we have in this thing called life, we have to time block. Time blocking is a simple technique in which something goes on your calendar, and that's *all* you do during that time. No multitasking. Not even dual tasking. One time block, one task. That's it. For example, if you've blocked off five thirty to six each morning for your devotional reading, and I show up at your house like the crazy person I am, what am I going to find you doing during that half hour? I'd better not catch you commenting on funny toddler videos! I'm only adamant about you following this rule because I obey it in my own life. And let me tell you something—it works.

WAIT TWENTY-FOUR HOURS BEFORE REPLYING TO A COMMITMENT

Have you ever responded to a girlfriend, a family member, or a co-worker and then minutes later wished you'd said something completely different? Maybe your boss asked you to work the weekend, and you quickly said yes—only to remember you'd promised your kid a trip to the mall. Maybe your cousin asked you to lunch, and you agreed—only to find yourself regretting it later that day because you already had a priority blocked out during that time. You love your cousin. I love mine, too, but I have to schedule a lunch out on the days that can accommodate it. When you guard your schedule, you'll see you have time to do fun things—if it's a priority.

When someone asks something of me, I give myself twenty-four hours to decide how to respond. It's amazing how the right answer

comes to you effortlessly when you give yourself enough headspace to think it through.

ACCEPT THAT NO MEANS NO

You're starting to get a handle on this boundary-setting thing. You're even embracing saying no. Like Matthew 5:37 says, let your yes be yes and your no, no. No *always* means no. When I say I'm not able to do something, people know I'm serious. I try to say yes any time I can, or at least give an alternative. But often the answer has to be a no, or else I'm not going to get done what needs to get done. This is hard for me, but applying these rules has helped so much. When you wait to answer a request, it gives you time to decide what you can do. If or when the answer is no, be firm. I would love to tell you that nobody pushes me around or guilts me into anything. It happens, but not very often. Accepting that no is always no also means that if someone asks you to do something that you do not feel is a 100 percent yes for you, your answer is no. And that no means no. No *always* means no.

PROTECT YOUR WHITE SPACE AT ALL COSTS

When things got hectic, I would find myself completely burned out. I needed to have time just to breathe during the day, either to catch up on a task or to decompress and do something for myself. So I started building white space into my calendar. I don't let any given day get too jam-packed with events and to-dos. Every day has some white space just for me, and I protect it the same as a scheduled appointment. It might be the single best thing I've ever done for my working self.

I'm a paper calendar kind of girl. If you use a digital calendar, same thing. Make sure you protect some free time for yourself on your schedule every day. Literally, every day. This might be an hour some days or a short twenty-minute nap other days. Write it down, time block it into

your calendar, and protect it. I don't always specify what I will use my white space for in a given day. I schedule my white space, and how I use it depends on what I need that day. It's a time I protect for self-care.

DISCIPLINE YOUR SPEECH

When was the last time you apologized to someone for being a hot mess? Or blamed your inability to be productive on undiagnosed ADHD? Repeating this negative dialogue is just an excuse that lets you opt out of discipline. You're basically saying, "I don't want to put in the effort, so instead I'll come up with an excuse that people in my life will accept." Well, guess what? True discipline doesn't allow for excuses. Didn't sleep enough? Your goal doesn't care. Feeling frazzled? Your boundaries still matter. Don't feel like getting off your behind? Do it anyway.

I have a friend who tags all her social media posts with #ADHD, #hotmessexpress, or #losingmymind. Can you imagine what that negative dialogue does to her confidence? It sure as heck doesn't help keep her disciplined enough to achieve her goals. I want you to know you are *not* a hot mess. You know what? Yesterday I couldn't find my glasses, and they were on my head. Most days I can't find my phone. Chances are that happens while I'm talking on it. I never remember where my keys are. Am I a hot mess? No. I'm a successful entrepreneur and an amazing wife and mother. We're all just human.

If you want to get things done in life, be disciplined in your speech. Don't tell yourself or others anything that gives you an excuse to break your boundaries, spend time on something not important, or abandon your goals. Are you going to get it right every day? No. But if you make this a discipline in your life, you will be amazed at how your days change for the better.

You know what? I can't stop thinking about those stupid hashtags. Especially the excuse that is ADHD. Whoa! Did I just say excuse? Yes, I did. I'm about to say something pretty controversial, and you don't have

to agree with me. Over the past decade, I've worked closely with dozens of women who claimed to have ADHD. It wasn't because of anything a physician said. Their lives are simply way too busy. Of course these women have a literal attention deficit; they're dividing their attention among dozens of tasks at once.

As a society, we've fallen back on a quick, easy fix of medicating people even when there is not an evidence-based reason to do so. It's easier to take a pill than to make a change. And it's not just prescriptions. Now more than ever it's wine o'clock somewhere for most women. Heck, when I'm stressed, I still medicate with M&Ms, cookies, and loaded cheese fries. You see where I'm going, right?

Here's the deal, friend. If you've never seen a doctor or been given a script for ADHD, let's not throw that around like we do the busy badge. It's offensive to those who are dealing with a true imbalance. Do I believe some people have a real diagnosis of ADHD? Yes. Do I also believe that as a society we are overmedicating and using terms that might not apply? Yes, I do. Everyone has days that don't go as planned. I cannot tell you the number of times that I've driven to Target and forgotten what I went there for. My mom worked like crazy when I was a kid. She would also drive to the grocery store and forget what she was supposed to bring home. I never thought for a second that she should take drugs to remember to pick up ingredients for the pot roast. Let's get a hold of ourselves. Take the busy badge off, drop the labels, and let's all just live, doing the best we can and focusing on what's important to each of us. You don't have to make excuses for the lack of discipline. Just decide to do better. For most of us, it's that simple.

My brother, Jeff, was crazy hyperactive as a kid. That didn't mesh well with my dad, who liked a calm house in which the focus could turn to him when he arrived home. My dad had strict rules and a loud voice, both of which went against Jeff's personality. My mom, on the other hand, was always joyful and energized. She's like that to this day. She let Jeff be the crazy, funny storyteller he naturally is. For years, Jeff walked a tightrope between our parents. One summer, Jeff went to visit our grandparents. They saw the way he was struggling, trying to please

both our mom and our dad. They saw how hyper he got and decided to stop giving him sugar. Two months later, he was a new person. Sounds simple, but it allowed him to feel the difference in his own body and to recognize how he responded when revved up on sugar. Life-changing for him and for our entire family.

Let's face it. As a society, we eat like crap. My cousin's daughter had a hyperactivity response to red dye. Once they figured it out and stopped letting her eat foods with Red 40 in them, she was calm and happy again.

Our brains aren't designed for this environment of fast food, social media, and constant notifications on our phones. We're being pulled in a thousand different directions, and we're bombarded constantly by things that say, "Look at me." Technology has convinced our species that we can take on more than we can possibly handle and that ketchup is a vegetable. It's no wonder people think there's something wrong with them. Don't buy into that feeling. If you decide what things are important in your life and establish boundaries around them, you can stop feeling so overwhelmed.

My last thought on ADHD. Yes, it is a real disorder, and if you have been diagnosed, there is no shame in that or in taking medication to help you. If you have any imbalance or are dealing with depression, anxiety, suicidal thoughts, or any mental health issues, please seek professional help. There is no shame in asking for help. Suicide is on the rise. If you ever have any suicidal thoughts, please don't brush it off, and please don't do anything to harm yourself. Talk to someone. If you don't feel comfortable talking to a family member or friend, please call the suicide prevention line at 1-800-273-8255.

MAINTAINING DISCIPLINE WITH GRACE

Some days, the seven rules fall into place perfectly. You'll tell people no when they push up against your boundaries. You'll decide you're

going to get that new customer before you arrive at the meeting. But some days, things are going to fall apart. You'll forget an appointment. You'll tell your husband what a mess you are. And your goal will seem so far out of reach.

Some days you'll get it right and some days you won't. While I want more than anything for you to stay disciplined, it's not going to happen 100 percent of the time. Forgive yourself. You're human, and you're allowed to make mistakes. Don't you dare use your bad days as an excuse to give up! Learn from your mistakes, get back on the horse, and do better the next day. Give yourself a lot of grace.

Because you deserve it.

CHAPTER 5

Make Friends Who Make Life Meaningful

Therefore encourage one another and build one another up, just as you are doing.

—*1 Thessalonians 5:11 (ESV)*

Friendship with other women can be tricky. Tricky and hard. Not the most encouraging way to start a chapter about making friends, is it? But I want to be honest with you. I've experienced it first-hand. At times I'm sure I made those friendships harder and trickier than they needed to be. Thankfully, I've learned some lessons along the way. Now my life is full of meaningful friendships, and I want to share a few secrets with you. Because after all, we're friends, right?

There's a big difference between being friendly with someone and being friends with them. In high school, I ate lunch with a group of deer hunters. All they talked about was hunting. I had no idea what they were discussing most days, but I found it fascinating at the same time. They ate, slept, and breathed hunting. They would go over their plans, discuss their strategies, compare their equipment, and share tales of their weekends. I knew pretty quickly I didn't want to marry a hunt-

er. But I loved learning about something new from these fellas. Truth be told, they didn't care about school and probably showed up only because they had to. They were on a different path from me, but I still loved eating lunch with them. This is a great example of how you can be friendly with a group even when they aren't necessarily *your group*. I believe it's important to get to know a lot of people, learning to like and understand those who are different from you. But when it comes to true friendships, your tell-all friends, those ride-or-die kind of people, you have to be selective.

That's why I encourage you to *friend up*. I'm not saying you should look at people and think, *I'm better than you, so we can't be friends*. Actually, quite the opposite. Wherever you go, I want you to find the person in the room who most emulates the kind of person you want to be. Once you find them, get to know them.

To friend up means to attract people you perceive as smarter than you, or better equipped in some way, or who possess qualities that you want to emulate. I want you to imagine a highly successful woman. Someone you think you couldn't possibly have anything to teach. Nothing that they don't already know. That's the type of person I want you to surround yourself with. Women who intimidate you. Women you have to be almost brave to talk to. If someone seems out of your league, start a conversation with her.

Because these women aren't smarter or better than you. They're just further along the same path that you want to walk. They simply have more experience than you do. And who better to get directions from than someone who's already been where you want to go? These people will help you rise up and advance in life. And they'll probably do so gladly. Successful, hardworking women want to help empower other women. They aren't intimidated by your success; they know there's room for everyone.

Having true-blue, ride-or-die girlfriends who make you aspire to be more is essential to showing up, working hard, and breaking through to the life you want. That's what I call friending up. As women, we need to raise our standards not only for *how* we spend our time but also for *who*

we spend it with. Because excitement breeds excitement, success breeds success, negativity breeds negativity, and mediocrity breeds mediocrity. I could go on, but you get the point.

Start being intentional about who you allow to influence your life. Friending up is just as much about what you do with your friends as it is who you hang out with. I'm not big on small talk or surface-level conversations because I simply don't have time for it. I want to be there for my friends in a meaningful way. A half hour chatting about the latest celebrity gossip is a half hour I could have invested in my business, my family, or my community.

Now, I don't want you to hear what I'm not saying. I'm not saying you can only be friends with people who are smarter or more successful than you. What I'm saying is if you want to have meaningful friend-ships, you have to look for people who help bring meaning to your life. If you love to decorate, getting to know an interior designer would be fascinating. Perhaps you love nature, so you get to know a person who hikes and knows about different outdoor sports. I have a friend who owns an antique store. I love antiques and I love learning from her about how her business is growing. I love learning from my homeschooling friends about how they connect with their children. It's improved my time with my kiddos—and the quality of their education.

I don't think for a second that I'm better than anyone else, but I do find that I'm drawn to people who have a similar growth mentality. Someone who looks for the positive in things. People who have innova-tive ways of thinking. Not someone who makes more money than me or has a higher degree. It's fine if they do, and it's fine if they don't. Those aren't the things that are important to me.

"My life is kinda ho-hum," a woman said to me once. "I don't have any friends who are very motivated, so I feel guilty for having big as-pirations. My friends make excuses for me. They seem to *like* that life isn't going anywhere. They enjoy complaining, but they don't want to do anything to fix their problems. I like my friends, but I want more out of life. And I want to go for it without feeling guilty because those around me are fine with the status quo."

Can you relate to that? I've heard a version of this story from many women. Friending down is what I call it. It sounds harsh when you read it in black and white, but it's a big problem. I experienced this when I finally stepped out to start my first business. The very people who I thought would be excited for me were negative toward my ideas. Was it jealousy? Fear? Or did they think it wasn't a good idea? Lord only knows. I didn't just drop those friends, but I did have to change the way I spent time with them. I had to be more selective about what I shared with them, and sadly, over time, I did grow apart from some of them.

I shy away from people who make excuses or who are overly negative. People who spend their time gossiping or talking about things they can't have any influence over. People who don't like you unless you agree with them. People who find what's wrong in every circumstance and complain about it. Now, I don't mind complaining, but if you're going to complain, offer a solution.

Why are friendships so tricky? As women, we think some crazy things that influence how we show up for our friends. We look at social media and make a lot of assumptions. We compare that woman's marriage to ours; we compare how their children behave to how ours do; we allow the things they have to seem somehow better than the very things we were happy with before we compared them to someone else's. Jealousy, feeling less than, or being under pressure to be something that we're not all play into the hard, tricky part of having good friends.

It wasn't until I became a mom that I realized comparing my world to other women's was like feeding my mind poison. I found myself dissatisfied with everything. I wasn't as creative with my nursery as others seemed to be. I wasn't a great breastfeeding mom. I had no idea how to make homemade baby food, and my first son was a terrible sleeper. And to top off feeling like the worst mom ever, I didn't enjoy being a stay-at-home mom. Worse, I *loathed* it. I loved my kids, but I didn't love not working outside the home. Pretty tricky when all my friends were telling me how happy I should be.

Let me tell you how I overcame this jealousy, fear, and comparison-filled world I was living in. I met a mom who was much further

down the line than me. She was battling cancer, and she was perfectly content with all the things that were not getting done. She was focused on her family—just being present with them and enjoying what time she had. It was beautiful to watch. It was refreshing. Her hair wasn't perfect, she didn't have a square meal prepared every evening, and she wasn't worried about what the world was thinking. She was simply present and choosing joy. Choosing joy during a time when she could have easily chosen despair. She could have let all the *why me* and *this isn't fair* thoughts consume her. And here I was, *not* fighting cancer and having a daily pity party. I was feeling sorry for myself. This mom was fighting for her life and still chose joy every day.

It was at her funeral that I decided I would choose joy every day. That I would not compare, that I would be happy for others and be happy for myself. That I could raise my family in a way that worked for us, and others could raise theirs in a way that worked for them, and we could all be successful mommas. It was then that I learned to find other people interesting. I learned to see people's differences as an opportunity to learn, not compare. It was the best lesson I've ever learned, and I'm so sorry it took a friend's death for me to realize it.

Does that mean you can flip a switch and, just like that, you'll find meaningful friendships? I wish. Friendship is still complicated. Let me share with you some practical ways to make friendship more meaningful. Let's see if we can't turn this tricky subject into the most meaningful part of your journey. That's what it's become for me.

MY RECIPE FOR GREAT FRIENDSHIPS

It needs to be guilt-free. I should probably apologize to all my friends everywhere for all the texts that I haven't returned. I hate to text, and some days I just don't get back to everyone. But my friends know this, and they don't hold it against me. If it's important, they know to call. Guilt-free means you *friend* in your way and let others friend in theirs.

It needs to be honest. If I say something offensive or completely inappropriate out of ignorance, don't be offended. Educate me. Help me. Be honest with me. Give me a chance to explain and allow me to make it right. Allow me to learn from my mistake.

It needs to have laughter. A *lot* of laughter. I love to laugh. I will get myself in trouble to make you laugh. I love to hear my friends laugh. You can't even make fun of me because I'll make fun of myself first. Of course, I might make fun of you, too. I'm like a fifth-grade boy. If I pick on you, it's because I like you—*a lot.*

It needs to have encouragement. Be careful sharing your wildest dreams with me, because I will encourage you to pursue them. I will give you all the support you could ever need, and I'll brainstorm with you forever. Just ask my friend who invented the pool noodle. Just kidding. I don't know that guy, but, man, am I proud of him!

It needs a lot of grace. Dose after dose of grace. Many days I get it right, and there are just as many that I don't. I trust that everyone is doing the best they can, and so am I. I believe everyone deserves grace. I give it freely and welcome it, too.

So, if you aren't completely scared to put yourself out there, let's talk about building a community of meaningful friendships.

Do you ever feel lonely? As I've told you, I have social anxiety. Nothing feels better than knowing my girlfriends will always make room for me in their circle. If I walk in late or need a place to sit, they're the first to say, "Over here. I saved you a seat." Be that friend. You'll be amazed by how much people appreciate being included, and magically, you will never be lonely again.

Believe it or not, a lot of ladies are lonely. Why? In a world where we are better connected than ever before, and more easily accessible than ever before, how can someone be lonely? Chances are they're hanging on to past hurts or regrets, and they're afraid to put themselves out there. They haven't found a community of women who support them and bring meaning to their lives. They want it, but they don't know how to find it. I understand. That used to be me.

I didn't realize how lonely I had been until I found my community.

I've been an entrepreneur for a long time, and before I was one, I was dreaming of being one. It's all I spent my time on. I had friends, but I didn't have a community of like-minded people who understood my way of thinking. I didn't have friends who understood the I-can't-go-out-today-because-I'm-working-on-a-project mentality. Once my first business got off the ground, I looked around and realized that I not only had built a business but also had gained a lot of great friends. Other entrepreneurs and self-starters. People who I could support with my gifts and talents, just as they could teach me things, too. It was the very thing I never knew I needed.

Then those friendships developed into a community of people who had a heart to serve others. That's when my team decided we were stronger together. We needed to start a do-good initiative. Because many of us were involved in skincare or wellness, we gave ourselves the slogan "Look good, feel good, do good." Because when you look good, you feel good; when you feel good, you do good; and when you do good, you make a difference in your family, in your community, and in the lives of those around you. We wanted to make a difference.

After a couple of years leading that initiative, I noticed I knew women not in my business circle who also loved serving others. I wanted to encourage them, but I didn't know exactly how to break in to their group. So I did what I do best. I started something new. It's a service organization called the Be Team. I know it's a hokey name, but I love it. I wanted to include women who had a heart to serve but who didn't have the community or capacity to do so. I wanted to include others in loving people and pointing them to Christ.

The Be Team started out of a shared desire to do something beyond building our businesses together. We wanted something more than friends to get pedicures with and to go on long coffee dates. We wanted to do something meaningful with other like-minded people and to find new ways of expressing gratitude, even when life wasn't going our way. So I suggested that we do a once-a-month ladies' gathering to support a local charity. Before I knew it, the Be Team took off.

Today we're a sisterhood of women who come together and serve through missions and charities. We come from all different backgrounds

and faiths. We encourage women to be confident, be bold, be *you*. We want to be the hands and feet of Jesus to those in our community.

When you're a part of a community like the Be Team, you're part of something bigger than yourself. You have something to strive for. You have opportunities to grow. It's more than just having friends. They're meaningful friendships with standards and a purpose. We don't waste time complaining about our husbands and kids over margaritas. We come together to serve our community. The Be Team brings us together to do something collectively that we couldn't (and probably wouldn't) do on our own.

In our first few months together, we made sack lunches for the homeless, collected new clothes for underprivileged children, and raised money for a charity that helps babies of drug-addicted mothers. Every time we get together to do good, I feel I am blessed so much more than the people we're helping. I remember handing a little boy a matching Star Wars hat and gloves. The huge grin that spread across his face just welled up in my heart so much. But the joy it brought to him was tenfold for me. It's such a good feeling to make a difference for other people.

It doesn't matter how successful you are; it's easy to fall into the comparison trap. Being of service to others stops you from getting wrapped up in your own problems because it makes you realize just how good your life is. For example, our adopted daughter has medical needs and requires a lot of day-to-day work. We are so fortunate and would never complain about taking care of her. During a recent trip to the children's hospital, I saw kids whose needs are ten times greater than hers. I realized that the old quote rings true. "If we all threw our problems in a pile and saw everyone else's, we'd grab ours back." Sometimes it takes seeing other people's circumstances to understand how good you have it.

Meaningful friendships encourage you to focus on who you're meant to be. Get beyond the past. Lay down your jealousy, your regrets, your guilt, and your shame. God doesn't want us to live a life saddled with those things. Decide who you want to be, and don't be afraid to dream

big. Then think about how God created you, and commit to using those gifts and talents. If you put yourself out there, you'll find a community of friends who want to help you succeed.

When you take the time to focus on helping others, you stop thinking about yourself for a while. And let's face it. We all go over and over our fears and failures. We have to stop. Stop telling ourselves lies that aren't true. Why do we lie to ourselves, anyway? My goodness, our minds can be used for so much good, yet so often we allow evil to sneak in. So many of us say things to ourselves that we would never say to another person. You know what happens when you feed your mind negative thoughts? You have negative outcomes. How do we stop this cycle?

What if we flipped the script? Let's tell ourselves what God believes about us. That we were made for a time such as this, that we were created in his image, that he loves us no matter what, and that if we rely on him, he will see us through. Ephesians 3:16–20 tells us that through prayer and faith, God dwells in us. Wow! He who is able will do more than we ask or can imagine. The creator of the universe, he dwells in us! Stop thinking small, my friend.

It's easy to get caught up in other people's achievements and compare them to our own. Yes, it's wonderful how that woman is building an orphanage, but is that what you are called to do? That calling is different for all of us. If you're called to be a stay-at-home mom, put all your best efforts there. What if you're raising an evangelist who will end up leading many people to Christ? Or a scientist who finds a cure for cancer? Sometimes it takes a community of friends to help you see your bigger picture.

Yes, you need to have boundaries. Yes, you need to focus on your goals. But how much easier will all that be with a community of support? With friends who empower you to make the best decisions in life? I think you're tired of being lonely. You're done with the guilt and the fear. Decide that you can make something great out of your life and accomplish your dreams. All dreams and all goals are worthy. You can get past worrying about what others will think and decide that what you

think is worth being heard. I know it can be overwhelming. Overhauling your self-image, your career, your life . . . I get it. So focus on what you can do now. Yes, the big picture is beautiful, but I don't want you just dreaming of it. I want you to take action. What can you do today to get you closer to where you want to be?

We know that small, daily accomplishments lead to a life well lived. Be present and focus on today. Be excited for your future and trust that you can do great things. Be confident in who God made you. Don't let past regrets determine who you are now or hold you back from your future. Be bold in your faith, trust God to help you become who he designed you to be—the very best version of you. Be confident, be bold, be you.

When I found the amazing women in the Be Team, my life changed. If you're going through life without fulfilling friendships, maybe what you need is a Be Team of your own.

HOW TO BUILD A COMMUNITY

How exactly do you start a community? What kind of women should you look for, and how do you find them? Surround yourself with people who are going where you want to go. You can start with the people you already know through church and other activities. Then expand your circle by joining meetup groups and volunteering at local food banks and charities.

Remember, it's not just about you. You're building a community by committing to doing something outside yourself. Like the Be Team, you could start with a tradition in your home that once a month you and your family find a way to serve others. You could also do this with a handful of coworkers. Or maybe with your ladies' Bible study or your Bunco group. Or with all of the above. You could volunteer at a dog shelter, serve the homeless, help out at your church, provide meals for a new pastor in town, or whatever serving your community looks like for you.

Anyone can take on the Be Team philosophy of coming together and going out to serve.

Even if you feel like you're alone, remember that you're not. There are so many women just like you who are also searching for their community. They don't have real friends to support them either. Sure, they have online friends. But liking and sharing on social media isn't enough. Coming together in a community and going together to serve is a whole different animal.

Start reaching out to people you know (and those you meet) and share your goal of building a community with them. Begin by dedicating yourself to a new cause, whether that's once a month or once a week. If you can't get any of your friends to join you, then it's time to friend up. For example, I have a friend who loves gardening, but she doesn't know anybody else who gardens. So I told her to join a gardening group.

"Look for whichever lady in the group is the most fascinating and interesting," I told her. "Then try to sit next to her at every single meeting. If you love or agree with something she says, tell her. If you don't understand something she says, ask her to explain it. People love to feel like experts and give advice. Then when you're ready to plant your garden, I'll bet that lady will volunteer to help you."

"That's good advice," she replied. "I probably would have just stood in the back, because I'm afraid of looking like an idiot. I know I won't know as much as the other people in the group."

"That's OK. Just ask questions."

Maybe you have a tendency to hang back, too. I get it. You don't want to say something stupid and make a fool of yourself. But you can listen, watch, and observe. Then when you find that person who knows what they're talking about, you can connect with them by asking them questions. Don't worry about coming up with things to say. Asking questions takes the pressure off you and lets the other person do the talking.

I'm always joking around, and I take every opportunity to say something funny. In fact, making people laugh is how I usually make new friends. But even I can feel awkward in a new setting with new people. So I observe, and I look for the most interesting person in the room who

enjoys a sense of humor. That's how I made my way through college, and I still use humor to connect with people today.

HOW TO SERVE YOUR COMMUNITY

To have a good friend is to be a good friend. So how do you show up for your people? How do you take care of your community and show compassion for your friends? Be aware. Remember, having a community isn't about you. Notice what other people have going on in their lives. Ask them about it. Ask how you can help with zero expectations of getting anything in return. If you want to be included, plan something and involve others. If you want to be heard, be a good listener. If you want to feel supported, make sure you're supporting others. If you have standards, respect other people's standards. Enjoy the differences in people. Find people who share your interests but who also introduce you to new things. Be slow to judge but quick to support.

I'm not saying show up to every event and outing and make your life crazy. Actually, quite the opposite. Like everything else, you have to put boundaries around the time you give away. If being social is one of your priorities, then you probably have more time to give. If serving is one of your priorities, you will need to decide how much time you can contribute. If you are like me and just hanging out isn't really your thing, the bonus to doing a service project is getting to socialize with your friends but in a purposeful way.

Does this make me sound like a bad friend? I don't think so. If a friend calls me for help, I'm glad to give it. If a friend needs someone to talk to or bounce ideas off, I'm your girl. But if you just want to shop or go out for drinks, chances are I'm not your first call, and I'm OK with that. My friends have learned that I like to be invited, but most likely I'll decline. Is it because I don't want to see my girlfriends? No, it's because I have prioritized my time and rarely leave space for just hanging out. That doesn't have to be you, but if it is, it's OK.

Here's an easy but meaningful way I like to show up for my friends.

If someone crosses my mind, I pause whatever I'm doing and send them a quick voice text, or if time allows, I call them. I know I'm a rare breed, but I love to have a true telephone conversation. My girlfriends know I'm going to call. They also know I won't hang on the phone for too long. Balancing friends and community with family and work isn't easy. You're not the only one guilty of pushing friends to the back burner when life gets hectic. When I'm not sure if I've been the best friend I could be, I ask myself the following questions: Have I been honest? Have I been fair? Have I given them all I have to give, and have I treated them the way I want to be treated? If I can say yes to all of those, I know I can rest easy. And if I can't answer yes, I make the effort to correct my mistakes. Sometimes that's hilarious and sometimes it's awful, but if you are honest with your intentions and offer an explanation or an apology when needed, your friends will respect that.

Let me tell you about a time I was trying to find my community of people and how quickly it went south.

When I was pregnant with our son Kyle, we started going to a new church. Our older son, Camden, was a little over two at the time, and he was more articulate than most grown men I know.

The church had a mom's group that met once a week. What better way to get to know these women? But after the first meeting, I wasn't so sure.

I told Michael, "These are not my people. They're lovely ladies, I'm sure, but they are not my people. They're so straightlaced. I can tell they don't get me. It's awkward and awful and I'm not going back."

Michael replied as he always does. "I think you're being overly dramatic. Everyone seemed so nice at church. Give it another try."

I sighed. "All right, I'll keep going, but I don't think these are my people."

I went back the next week and came home feeling pretty much the same as I had the first time. Still, Michael had asked me to give them a chance. Two meetings was hardly a real chance.

When Camden and I arrived at the third meeting, the room was different. All the chairs had been pushed back, and the moms were seated on the floor in a circle. I learned that this week we were doing story time

with, well, we'll call her Ms. Joy.

"All right, kids," Ms. Joy said. "Find your mommy's lap. It's time to read a story!"

Camden followed her direction and climbed into my lap.

Ms. Joy started reading a book. Something about animals. Then she said, "That's right, kiddos, fish swim! Can you pretend to be a fish?"

I watched as Camden and the other kids made swimming motions with their arms and fishy faces at their moms. So cute. I smiled along.

Then Ms. Joy pointed to a picture of an elephant. "Elephants have big ears! Can you find mommy's ears?" Camden giggled and turned around to pull on my ears. *Maybe this group isn't so bad after all,* I thought.

"Now, bears have fur! Have you ever seen an animal with fur?"

Camden raised his hand excitedly. Remember how I said that he was super articulate?

"Yes, Camden?"

Camden smiled confidently, and in his loudest, proudest voice, said, "My daddy has fur on his penis!"

What? I wanted to die.

The room fell silent.

All the moms sat there with bug eyes.

I was mortified, but I tried not to show it. Through nervous laughter I said, "Um, what's the next animal in the book, Ms. Joy?"

Ms. Joy just stared at me. The other moms started looking away awkwardly. It felt like the longest few seconds of my life.

Why does no one think this is funny? I thought. *Oh my gracious sakes, this is not my crowd.* Somehow, the story finally continued, and then it ended, thankfully. As soon as the meeting was over, Camden and I were the first out the door.

I called Michael on the way home.

"How did it go today?" he asked me.

"Apparently the other men at church are far better groomed than you," I replied. "Because the women were all shocked to hear you have fur on your penis."

"Uh, what? Fur on my penis? What, I don't have fur . . . what happened?"

I told him the entire story. I reminded him that this was his idea, that I knew these weren't my people, and that I would not be going back.

Looking back, it's hilarious to me now. But on that day I could have used some grace. Was that an appropriate thing for Camden to say at story time? No. Could a two-year-old be expected to know better? Not really. But you know what? I'm friends with one mom from that group. She's still way more straightlaced than me, but she's a darling. Even though going to those group meetings was an unpleasant, mortifying experience, I still managed to salvage one friend out of it. That's a win in my book.

We still attend services at that church, and we love it. It feels like the ladies still avoid my gaze when they see us coming every Sunday, though, and I swear some of them even blush when they see Michael.

I find it's a lot easier to be open, understanding, and forgiving of others when you're not all wrapped up in your own problems. When you have a community of friends all striving to make your corner of the world a little better, you gain a lot of perspective. And sometimes the person you need to give the most grace to is yourself. Oh, and for the record, Michael would like me to tell you he does not have any fur anywhere. But if you see him, feel free to call him Furry Bear. I do!

CHAPTER 6

What Makes You Different Makes You Great

Before I formed you in the womb I knew you, and before you were born I consecrated you; I appointed you a prophet to the nations.

—Jeremiah 1:5 (ESV)

The other night at a basketball game, I sat next to a group of Muslim ladies I hadn't met before. I didn't know much about their culture, so I struck up a conversation. We talked about our kids, our families, our interests. We talked about how we spend our family evenings and how we make time to take care of ourselves. Sure, they were different from me. That was half the fun of the conversation.

What makes people different is what makes them interesting. My whole life, I've always looked for the people who don't look like me, act like me, or talk like me. I've chosen to insert myself into groups of diverse people. If I only hung out with people who held all the same beliefs I do, I wouldn't meet people who make me question the status quo, challenge my thinking, and look beyond my everyday life.

The only danger in seeking out people different from you is developing a chameleon complex. If you don't know what you believe or who you are, you ascribe to whatever those you associate with do. Remember the 1990s goth phase? A lot of girls wanted to be cool and look different, so they dyed their hair jet black, wore only black clothing, and congregated only with other goth people. In an effort to look different, they ended up looking the same. If you know who you are, then you know you don't have to change yourself to match the people you meet. You can embrace and celebrate differences of all kinds.

Find the balance between consistency in what you believe and openness to new ideas. What you think may not change my opinion, especially if it's about my faith, but that doesn't mean I don't want to hear your point of view. Most likely, I will find your thoughts fascinating. I'll always be respectful of who you are and what you believe.

What drew me to the deer hunters at my high school lunch table and to the Muslims at the basketball game was their confidence in who they were. They comfortably owned their identity without apology, and that drew me in. You can own who you are, too. You can draw the right people and opportunities into your life when you're authentically being who you are.

I'm not saying you should wave your opinions in people's faces or never shift your actions when you gather new information. Outside this book and my coaching business, I usually keep my personal views close to the vest. The last thing I want is to be unintentionally offensive. Not everyone is as hard to offend as I am. Of course I find some things offensive, but these days, so many people are offended by the slightest thing. Sure, some people enjoy controversy and good debate. They deliberately say something to get a rise and trigger conflict, but most of us have no idea if we're politically correct or not. I could easily say something inappropriate just based on a lack of knowledge or understanding. I'm the first to admit that I don't know everything about every other culture. Not knowing doesn't keep me from wanting to interact with people different from me. It does open the gates for possibly offending someone or saying something stupid. I promise you, it's unintentional.

And for gracious sakes, educate me. Help me do better. Just getting mad doesn't help either of us. I was recently in an elevator and offered directions to another passenger who kept pressing buttons on the way up. She assumed I'd offered because she was a different race. She was so offended. She told me, "You think I don't belong here." Nope, I was just trying to help. If you're looking for offense, you're going to find it.

Bottom line is, you can take ownership of who you are without ascribing ill intent to those who are different or getting flustered about fitting in with the crowd. I have a group of girlfriends who love to drink. They still invite me to go to parties, but they know I'll most likely be the last one to arrive and the first one to leave. I pass no judgment on them if they've had more than a cocktail or two, and they pass no judgment on me for drinking Coca-Cola all evening and ducking out early. It's a mutual understanding that works for them and for me. One of them will pressure me every once in a while. It's funny how alcohol is the only drug we have to justify not using.

You're probably wondering why I don't drink. If you know me personally, you have probably seen me have a drink or carry a glass of champagne here or there. So let's clear this up. I'm not opposed to alcohol, but I've learned that it doesn't serve me well. I used to enjoy a cocktail or two at a girls' gathering, but I've found that when I drank the third, I might as well have had ten. My laugh got louder, the stories got bigger, and I went home regretting my behavior . . . all of it. It just isn't good for me. So I don't drink. Now, if I'm walking into a party or getting ready for a champagne toast at an event, and the waitress hands me a glass, sure, I'll take it. I might sip for the toast. More likely, I will set it down on the next table I pass. Why accept the drink in the first place? It's easier and less awkward for those around me. I'm not trying to be deceitful, but I'm also not waving a self-righteous flag. I don't mind if you drink, but for some reason, it bothers others if I don't.

Maybe alcohol doesn't serve you well either. Only you can decide. If you're struggling with alcohol or addiction of any kind, get help. Addiction is real. It takes help to overcome this disease. If you need this advice, take it.

Here's what I've learned. You can be yourself, avoid peer pressure, and be respectful of others all at the same time. Michael and I have close friends who are German Baptists. When we have dinner with them, I don't wear blue jeans and a sleeveless top like I might if we invited the neighbors over.

Years ago, Michael saw me wearing a long skirt and modest sweater, different from what I would normally wear out to dinner with friends.

"Why are you wearing that? I feel like you're being inauthentic."

"I'm being respectful," I said. "I'm not trying to be somebody I'm not, but I want to respect our friends."

Now, if I'd gone out and bought a prayer covering, that would be going chameleon. See the difference?

Being yourself, embracing everyone's differences (including your own), and respecting others requires a strong understanding of who you are. It requires space for nuances in our lives. Our social media-enabled age removes nuance. Everything is either real or fake, black or white, good or bad. This binary thinking has squashed our open-mindedness. If more people knew who they were, accepted others as they are, and realized that what makes us different makes us great, I wouldn't have to write this chapter.

How do you live an authentic life while keeping an open mind?

In order to know and appreciate your differences, you need to know who you are. When and where are you most comfortable? When are you most proud of yourself? What makes you feel alive? What makes you feel accomplished? What do you enjoy most? What activity did you leave exhausted from in the best way instead of feeling anxious and heavy from participating in it? How would you spend all day if you could? There are certain activities I've been invited to that I *never* show up to—because it does not in any way represent who I am. It doesn't answer any of the questions in this paragraph. Over time, this self-reflection helps you figure out who you are and what sets you apart, not in a way that says, "I'm better than you" but in a way that says, "I respect you for you and I'm good with me being me."

I have a friend who is an amazing writer, but she lets self-doubt stand in her way. She told me that she and I have had three conversations over the last four years that were defining moments in her life. I simply challenged her to think differently about herself. I asked her three questions that I just asked you: When are you most creative? When are you most productive? How would you spend all day if you could? For her, the answer was writing. That question challenged her to write when she feels most creative—between two and four in the afternoon. She had been telling herself she couldn't have that time because her kids got off the bus at two thirty. She felt like she had to have her work wrapped up by then. Not necessarily. What if she could arrange for childcare from two thirty to four? Just asking that question flip-flopped her errands, her childcare, everything. Today, my friend is living authentic to herself, writing every day during the time she once thought belonged to her kids' schedule.

Not all deep self-discovery questions lead to flashes of insight. In coaching women, I've found that two little words, when wiggled into a question, lead to all the wrong answers.

"Jessica, when should I get up in the morning? When should I start working for the day? How should I open a sales conversation?"

The should-I questions often come up when a person is asking for advice from an expert. They want that expert to tell them what to do. If you find yourself asking should-I questions, that tells me you haven't fully explored who you are in that area. Find your uniqueness. Figure out who you are. Then come back to the question. Because what works for some people will not work for others. The industry you'll be most happy working in is not necessarily the same industry someone else should be in. This applies to all areas of life. Which diet should you follow? Well, I can't tell you that. What's your body composition? Your genetics? Lead yourself to the right answer for you. And it probably *should* be different from mine.

Don't get me wrong, you can learn how others do things but when it comes to "should I" do this or that. You're the only one who can

answer that question authentically. If people are answering you with "you should," I would question their motives or place of authority. As a coach, I prefer questions like "Have you considered these things? When are you most creative? When are you most productive? When could you work on this project? Do you find yourself drawn to it more and more? How will you feel if you don't do it? What is your hesitation in starting?" Once you answer those, you'll know if you should do it or not.

Even if we're talking about diet, exercise, or perhaps a little weight loss, should you make changes in these areas? I don't know, but asking yourself a few questions can set you up for success. When are you most creative? Maybe that is when you can meal prep. When are you most productive? Perhaps that's a time to take an exercise class or establish your new routine. When can you work on this goal? Look at your schedule. If you're traveling for the next three weeks, that's typically not a time to embrace a fitness goal or diet change. Do you find yourself drawn back to this thought process over and over? Then you probably should take action on it. You will feel so accomplished if you take the first steps toward making progress in this area.

Another approach I like to use for self-discovery is the inch by inch ruler method. I just made that name up, but I love how official it sounds. You can use this in a sales call or when making a life decision. I tell my team to think of a sales call as moving someone down a ruler, inch by inch. The first three inches on that ruler are opening questions. Then you ask a question based on their answers. Then they ask questions. That's how you move down the ruler. When you get all the way down the ruler, you can either take someone to the close or set a time to follow up if they're not ready to make a decision.

If we want to help ourselves answer our should-I questions, we have to move ourselves down the ruler of self-discovery. For example, Michael has a friend who doesn't know if he wants to have children. He could reach a decision by asking himself if he enjoys spending time with babies and toddlers. Has he ever looked after cousins or nieces and nephews? How did he feel having them in his care? How does he feel about being

responsible for providing for another human being? Has he imagined his life twenty years down the road with no heirs? How does he feel when he thinks about not having kids? Does he even find these little rug rats adorable, or does he not even notice when a baby is in the room?

Every time you find yourself asking a should-I question, no matter what it is, you can find the answer yourself by asking questions that move yourself down the ruler. When you know who you are and what you want, you'll be able to answer these questions and in turn settle into your authentic self.

Knowing who you are and what you stand for will help you make the right decisions for your life. And if your track record isn't that great, the good news is that it's never too late to start self-discovery and begin working toward better decisions. We all made bad decisions in our past. No one is alone in this. It's what you learn from those mistakes that can help you change your future decision-making skills. You can have all the potential in the world, but if it's saddled with terrible choices, you will never live up to who you were meant to be. Only you can decide to move past those poor decisions and look for ways to improve from where you are now.

CHAPTER 7

Mindset Trumps Skill Set

Do not be conformed to this world, but be transformed by the renewal of your mind, that by testing you may discern what is the will of God, what is good and acceptable and perfect.

—*Romans 12:2 (ESV)*

Have you ever wondered why someone was successful when you weren't? You did the exact same things they did. Why weren't you getting the same results? I doubt they had any secret talent or opportunity you didn't know about. No magic pill, no silver bullet. Chances are they just had a different mindset.

I grew up in a small town in Tennessee, and sports were important to that community. It was a place to gather, see friends and family, and enjoy an evening of supporting one another. I mentioned earlier how great an athlete my sister was. She was someone who people came out to watch. Sadly, my basketball career started and ended on the same day.

It went something like this:

Freshman year, my biology teacher had been my sister's coach. Because I was a Gayhart and both my brother and my sister were great athletes, it was assumed that I was, too.

So, this coach said, "I'll see you at tryouts," and because my sister was helping with the tryouts and I knew she was my ride home, I agreed. Plus, I didn't want to be disrespectful to my teacher. Here's the problem—well, there were several, but my complete lack of talent wasn't even the worst of them. I had a terrible mindset. I went in expecting to get cut. I arrived with zero confidence and zero desire to give it my best. I was defeated before I ever walked onto the court. Now, I'm not saying I would have made the team, but I do wonder if I would have enjoyed the experience a bit more had I gone in and tried my hardest.

Here's the deal. It wasn't easy following in my brother's and sister's shadows. They were not only great athletes but also super popular, and they were both straight A students. I was thrilled with barely Bs. Again, could I have tried harder? Absolutely, but it just didn't feel worth it to me. I look back now and realize it was all in my head. I let what I assumed others expected of me keep me from showing up with my best effort. I didn't feel like my best was good enough, so I didn't even try.

I had a friend in high school who was also known for being a phenomenal athlete. He, too, was a straight A student. He was also very charismatic, and our town adored him. When he was playing, people would show up from all across the state. He was recruited to play for Division 1 schools all across the country. He had service academies chasing him, and he had scouts in the stands starting his freshman year. This kid was a half-court shooter, and after the ball left his hand, he turned and went the other way. He didn't even have to watch; he knew he had landed the shot.

He and I were great friends, and when the time came for me to leave for Colorado, he gave me a dose of reality. He confirmed what I worried people thought of me. He said, "Jessica, you are never going to make it out there. When you get back to this side of the country, come watch me play ball." It stung. I don't think he was trying to tear me down, but it hurt. He knew I was enrolled in a community college, and I felt embarrassed by that as well, especially when he showed me the boxful of recruitment letters he had received.

In the end, life didn't turn out the way anyone would have expected for this guy. The entire town had worshipped him, but it was to his det-

riment. They allowed him to believe great things about himself. They were true, but they left him with no follow-through or backup plan if things didn't go his way.

He was so used to being known and beloved everywhere he went, and now he was just one among many. After just a few months away at school, he decided he wasn't cut out for that type of pressure. He had more skills than you could imagine. I can hear some of those good old boys now. *I'd give anything to have half his talent.* Talent isn't enough if you don't have the mental toughness you need to stick it out.

I was happy to see him when I visited home at Christmas, but he wasn't quite the same. His spirit seemed to be broken. I know he was disappointed, and he felt like he let our town down.

Years later, he ended up in trouble with the law. He got mixed up with drugs, and sadly, he passed away. It breaks my heart to think about him. He had everything at his fingertips, but he just couldn't handle the pressures of the real world after high school.

We lost touch after college, but I heard that he gave his life to Christ. Just because you become a Christian doesn't mean all life's troubles go away. His addiction was real, and it had a strong grip on his life. If you or someone you know is struggling with addiction, get help. Addiction doesn't discriminate. This boy was smart, he came from an affluent family, and he had opportunities galore. I am brokenhearted for his family. I hate that his life turned out this way. I am so thankful for the assurance of heaven to see him whole and well again someday.

THE (UN)IMPORTANCE OF SKILLS

People never looked at me as having potential, and not only in sports. I was just barely better than average in school, but I had a lot of friends. I was social as all get out. That's the only reason I showed up to anything. Grade-wise, I just squeaked by at the lowest standard that I could get away with at home. No one expected me to amount to much.

Except my momma, Miss Edna at church, and Debra Graham. Thank goodness for strong female role models. I'm sure there were days when even those three doubted my potential. I was a bit of a wild card. On paper, I didn't have the skills to succeed. But I've always had the mindset to figure things out.

It's been my experience that the right mindset trumps the right skill set every time. Except maybe in brain surgery! But in day-to-day life, in business, and in relationships, having the right mindset will always set you up for success. You can always learn the skills. And with the right mindset, you'll learn the skills easier and better.

People tell me I must be so proud of how smart my boys are. I mean, I'm super thankful they're so smart, and I pray they recognize their God-given talents and abilities and use them to their fullest. Camden and Kyle have genius IQs, but I'm not proud of their intelligence at all. I had nothing to do with that. I'm not trying to be humble or say, "I'm not smart, so they must have gotten it from their father." Michael and I can't take credit for how smart they are. They were born natural learners, and God gave them great intelligence. What I *am* proud of is how they use their intelligence. I'm proud of their character, of how kind they are, and of how they treat others. Those are the things we can be proud of.

They also have the right mindset. We try to help them understand how fortunate they are and how they can't rely on intelligence alone. You can be the smartest person in the world, but if you do nothing with it, what good is it? If you rely on being smart but have no drive or determination, how far will you go? If you have the highest IQ but no work ethic to go with it, then you might as well be average. You're better off being average with drive than a lazy genius. I'm living proof of that.

My kids are also humble. I give Michael credit for that one.

"You're not smarter than anyone else," he'd say to them, "you just have the ability to learn things faster and easier. But given the opportunity, others can learn what you can learn. It may take them longer, but once they learn it, you are equal. It's how you apply your intelligence that will make the difference."

Mindset isn't easily tested or displayed like academic achievements.

You don't get awards or scholarships for having the right mindset. Mindset is invisible. You can have the same skill set as everyone else, but with the right mindset, you can do more with them—and learn new skills as well. Your improved performance will be visible, though sometimes the reason behind it will remain hidden. People won't know why you're finding more success. They'll compare your skill set to theirs and believe they're the same. How can I be so sure?

Here's an example of mindset beating skill set. I know a darling woman named Tina, who is a quadriplegic. She wrote her ninety-seven-page master's thesis at six words per minute using an onscreen keyboard and head mouse. Her story is so inspiring. Maybe someday I'll get to share more of it. Here's the part that I want you to think about. She doesn't have the use of her legs or arms. Most of us do, but we're intimidated by writing a thesis. Not Tina. She knew she needed her master's to have the career she wanted. How many in her class finished their thesis in a fraction of the time? How many did anything with it? I don't know the stats for her specific class, but plenty of people have degrees and titles but do nothing with them. Not Tina. She became a phenomenal social worker and owns her own business in another field. It takes her up to four hours to get ready each day. She has an assistant who has to help her get from her bed to her chair and do all her self-care. But Tina knows it's worth it. Others in her situation might just lie in bed and give up. But Tina has the right mindset. She knows her voice can reach people and do good in the world.

JUST GOOD ENOUGH ISN'T GOOD ENOUGH

Most people reading this book have the use of all four limbs, so we have quite a few skills over Tina already. Still, that's not enough. I knew I had the skill set to take care of a child with many medical needs, but I needed the mindset to be willing to do it. Sometimes people see how much effort it takes to make things right for our daughter, and they say, "But, Jessica, no matter what you do for her, she has it better with you

than she did before." Although this may be true, I don't want her life to be just good enough. I have a mindset that says, *I'll do whatever it takes to care for my daughter and to give her the best chance at a healthy, happy life*.

Mindset is exactly the same for our careers and finances. We can't settle for a just good enough mindset. We have to believe we can do whatever it takes, no matter what. Remember comparison syndrome? People often compare themselves to someone with a bigger house, a higher income, a prettier lawn, or whatever. They say they can't be like whoever they're comparing themselves to. You know why? Because they've already adopted a mindset that tells them they can't, so they don't try. They settle. What if instead of settling, we did something about our circumstances? Let's focus on what we can do, not on what we can't. Don't settle for just good enough. Decide now that you're going to do whatever it takes for the best possible outcome.

The right mindset doesn't remove your obstacles, but it makes them a heck of a lot easier to tackle. If you're not a great public speaker, then choose a career that lets you talk to people one-on-one. Or do what my grandpa did—join Toastmasters or take a public speaking class. If you can't work evenings, find some time on a Saturday or Sunday. If your job depends on networking and you feel like you have talked to everyone you know, look for ways to meet new people. If you don't have a bold personality, that's OK. You don't have to be big and loud; you just have to be you.

A growth mindset involves doing the work, evaluating what went right and what didn't, and making adjustments. Here's where I think people go wrong. They take the stance of a student; they are willing to learn, someone teaches them something, but they don't apply what they have been taught. It's a lot like going to a feel-good conference, learning something new but never applying it. Knowing but not doing is the same as not knowing. The other dangerous spot we can find ourselves in is when we do only what is expected or what we've been told to do. It's the lack of initiative to push yourself further to determine what you might be capable of accomplishing. If you want your circumstance to

change, prove to yourself you are capable of doing more than what you have been taught or told to do. After all, life doesn't come with step-by-step instructions.

EVERY PROBLEM HAS A SOLUTION

If you're dabbling in a new job, or you have no confidence behind your decisions, or you second-guess yourself all the time, people will pick up on that. If you complain to your sister, mom, coworker, brother, and uncle's best friend every time something doesn't go your way, these people probably won't want to offer you much support. When I hear someone complaining about anything, my first thought is, *What are you going to do about it?* Instead of focusing on what's wrong, focus on what you can do to change the things you don't like.

In my industry, many women have similar skill levels, but some outperform others by a large margin. Those who outperform act differently. They're not more proper or well behaved. They simply *own* the business. They own the good and handle the bad through problem-solving. They believe in themselves and trust that this is right for them. They don't waver in tough times; they stay steady and committed. They don't have down months; they have down moments. I hate when someone says, "This just isn't a good month." How do you know? It's not over yet. Get to work and make it a great month. When you tell yourself those negative things, it's negative in, negative out. You may not realize how much your mind can work for you or against you in life and in business.

I know an amazing salesperson in my industry, and she's decided that being an entrepreneur may not be for her. That's OK. If it's not for you, it's not for you. But often the internal dialogue you have will dictate your outcome in business more than your skill set. Look at my life. I probably should have never had the success that I've achieved, but my mindset told me, *Of course you can do it. Get out there and try. How hard can it be? If she can do it, you can do it.* Instead of looking only at the problems, I focused on the solutions.

95

YOU HAVE TO WANT IT

Our oldest son, Camden, is the kindest boy. We call him our gentle giant. He's six foot six, and growing up, Michael wanted him to play basketball. So Michael got Camden a hoop and a ball to introduce him to the game, and Michael encouraged him to go out and practice free throws. Eventually Camden told Michael he didn't want to keep practicing because he already knew how to shoot free throws. Still, Michael wanted him to practice and practice and keep getting better. We soon realized that Camden didn't want to master this skill. He'd learned enough, and he was done. We saw something totally different with his academics. No matter how much he learned, he always wanted to dig deeper. His fifth-grade math teacher told us sometimes he had to look up answers to Camden's questions because he wasn't always sure how to teach or explain it.

Camden probably could've learned the skill set to play basketball. He's a head taller than anyone else in his class, and that's a big advantage right there. But he just didn't have the mindset to be successful in that sport because he didn't want to. Yet he was willing to stay the course, dig deeper, and be resilient in math and other subjects because he loves and excels in them. We parents have to be aware of those things. Not that we should allow them to just throw in the towel all the time. But we should recognize where they want to keep going, showing them the mindset they need to be successful, instead of pressuring them into something they have no interest in.

We have a friend whose son plays baseball and football, and he hates both of them. But his dad won't hear of him stopping. Now he's heading off to college, and his parents are just devastated that he hasn't gotten a scholarship for either sport. The truth is, he's not good in either sport. They've pressured him to play when it's of no interest to him. Mindset trumps skill set, especially when you recognize something you want to excel in and you're willing to stick with it to overcome the obstacles. There will always be frustrations, and you may still feel like you want to quit. But when it's something you want, you'll feel like what you're

doing is worth the fight you're currently in.

In my business, I look for team members who have that resilience. I can teach somebody how to sell. I can teach them how to have a sales call. You can always learn more skills. But if in addition to those skills you don't have the mindset to be resilient, then you're not going to be able to do much with them.

I had a conversation with one of my team members who was having a killer month. I mean, just blowing it out of the water. There's nothing that makes her better than anyone else. She doesn't have some super big network. She wears a messy bun the way I wear a messy bun. She's just an average, normal girl, but she's convinced that this business is going to be the very thing that changes her family's life. They're not in a bad circumstance, but she doesn't want to trade long hours for money anymore. She doesn't want to watch her husband drive away every day and work fourteen hours. She would love to see him follow his dream of starting his own business and work for himself. So she's committed to this business. The crazy thing is, she's had big disappointments. She's had people let her down. She's had customers who she thought were going to be great and they weren't. She's had teammates who she thought were going to be great and they weren't. She has dealt with some hard customer complaints. I think the reason she's been so successful is that she doesn't take anything personally. She's resilient, she's determined, she wants it, and she tells herself every day that this business is worth fighting for, that stepping out of her comfort zone is worth it.

SOMEONE ELSE'S NO ISN'T ABOUT YOU

In my sales world, people get so nervous when somebody tells them no. They won't even ask questions because they're so wounded by the no. Listen up, friend. When someone tells you no, it has nothing to do with you and everything to do with them. If you are asking someone to do something, then understand they might say no. You have no idea what another person has going on in their life. Taking that no personally

is crazy, really. Actually, no is a great answer. Because any answer at all is a great answer. I would rather hear something back than nothing. Yet many people in sales are more comfortable hearing nothing than no. It's interesting how some people won't do the hard things. Maybe they've never had to face adversity. Maybe they've never had to struggle. Then I can't think of a better place for them to learn than in a sales job.

Many new people on my team don't want to start making calls because they don't want to get that no. That's why we're there to support them. "Go ahead and attempt the call. If you call this person and they say no, it's OK." What's your hesitation? What's your worry? What's the good, what's the bad, and what could possibly go wrong? People usually have the answers within themselves already; they just need help to drum it up.

I don't care what industry you work in or who your friends are—nobody likes hearing no. When someone tells you no, don't take it personally. Don't let it ruffle your feathers or ruin your day. It's not about you. Here's a little bonus tip for you. How you handle the no will determine whether it turns into a yes. If you are gracious, allow people to say no, and continue to be kind, you will be surprised by the number of people who come back to you and want to be a part of what you are doing.

HOW TO ROLE-PLAY LIKE A BOSS

My kids have never had to struggle. Camden's college application asked him to share one of his toughest moments. I told him to be honest. Tell them that finding twenty-nine-by-thirty-six-inch pants has been your toughest task to date.

When my children get out into the real world and come up against who knows what, I want to feel confident that we've equipped them with a resilient mindset to push through and stay the course. I believe all parents want their children to learn how to take care of themselves. Home is where they can practice. Once you get in the real world, you have to find resilience on your own. There are a couple

of things you can do to build your confidence and step into whatever situation you're facing. Whether you're guiding your family, your team, or yourself to learn something new, use role-play as a tool to help prepare for any circumstance.

This activity goes back to my days as a pharmaceutical sales rep. The money was good and so was I, but I hated every ounce of that job. Selling for Big Pharma felt like selling my soul. Still, that job taught me the power of role-play, which ultimately sent me rocketing to the top of the sales leaderboard.

One evening when I had first started, my friend Carrie was meeting me for dinner. I was just finishing up with a customer when she arrived.

"Why were you talking so fast and practically yelling at that customer?" Carrie asked me.

"I don't know. I guess because I was nervous."

The next evening when Michael and I went for a walk, I asked him to role-play with me. I told him three objections I wanted him to give me so that I could practice handling them. And he did this with me, evening after evening, until I wasn't yelling anymore. Carrie taught me that you have to sell to the needs of the person. You have to ask questions, find out what's important to them, and then calmly address their concerns. The way to do it calmly is to practice through role-playing.

Let me expand on selling to the need. If I'm talking about price and all my customer cares about is efficacy, then I'm chasing the wrong rabbit. Or vice versa, if I'm talking about how effective a drug is, and the doctor wants to know only if their patients can afford it, I'm not selling to the need. If you take the time to role-play and get confident in your verbiage, it will allow you to slow down, ask the right questions, listen to the answers, and then respond appropriately.

That is how you role-play for a sales call, but role-playing works in all areas of life. I still role-play with my children before we go somewhere new or meet someone for the first time. It's one of our parenting techniques I'm most proud of.

"You're going to see Dr. Roer today. He's going to ask you some questions. It's important that you look him in the eye and that you an-

swer the questions. Mom will be there to help, but I expect you to tell him what you are seeing him for today. Before we arrive, tell me what you are going to say to him."

If we are visiting family friends, we remind the kids how we know them. We practice greetings and other sample phrases ahead of time so that they're not standing there like a deer in headlights. Knowing what's expected of them helps them walk in with confidence. This has had a good influence on the kids. It encourages the idea that it's important to think about situations ahead of time.

I also role-play with myself before I get on a sales call. I role-play before I go to a social engagement to kind of psych myself up. When you have social anxiety like I do, you worry about saying the wrong thing. If you role-play before you get there, you make sure that you don't say something you might regret. Somehow I still do. Can you imagine if I didn't role-play?

At the time of this writing, Michael and I are moving into a new home we built. Everywhere I go, people ask me about the house. I'm excited and proud of the house, but I'm also a little private about it. It's big. It's more than I ever dreamed I would have. I don't want to be boastful. So I role-play what I'm going to say, and I've come up with answers that feel comfortable to me.

Having a spouse, partner, friend, or team member you can role-play with makes a big difference. Someone who will be honest with you and who isn't worried about offending you. You know those kids who end up on *American Idol*? The ones who, bless their hearts, are just awful singers? They end up there because their moms tell them they're great singers, even though they just can't sing. When you're looking for honest feedback, you can't rely on just one person. It can't be only your mom who's always telling you that you're perfect.

Think of it as a good pregame, almost like stretching or shooting layups. Afterward, I do a postgame analysis—I critique myself on how it went, fine-tuning a little for the next time. The postgame is important to do right away because it builds your confidence to know how to improve. Is there an area for follow up? Maybe you had a great conversa-

tion with someone and you want to send them a note of thanks. Maybe you thought you were having a nice conversation but you unintentionally offended someone and you need to have a follow-up conversation with them.

That happened to me a couple of weeks ago. I was at a dinner party when a girl shared with me some details about her prayer life. Unknowingly, I said something that offended her. Thankfully, we were sitting across the table from one another, so I could tell by the look on her face that my comment hadn't been received the way I'd thought it would be. I'm a communicator, and I like to make sure that I'm coming across the way I intend. Of course, I didn't expect anyone to talk to me about praying, so I hadn't role-played any of that conversation. I quickly apologized for what came across as condescending and asked her a few clarifying questions. This got her talking about positive things, took the pressure off me, and lifted the awkwardness—sorta. You can bet I went over that conversation in my postgame right away. I wish that was the only example I could give you. There are plenty more, but I will spare you the details. Just know that we all have awkward moments, but role-playing really does help you feel more confident and prepared.

We're all the same, and we're very different. I know that's a confusing statement, but hear me out. At either extreme, great or awful, there are people who have faced harder tragedies or had bigger wins than any of us. But for the most part, we're all the same. We've all had rejection, we've all had setbacks, and we've all had disappointments. It's what we do with those experiences that will set us apart.

It's the mindset we adopt that determines whether we succeed. Will you?

CHAPTER 8

You're Qualified for Your Dreams

For we are his workmanship, created in Christ Jesus for good works, which God prepared beforehand, that we should walk in them.

—*Ephesians 2:10 (ESV)*

When Michael and I were young newlyweds without kids, I was working as a nurse in a plastic surgeon's office, and I loved my job. Taking care of patients and setting up the surgeon for success gave me a great sense of accomplishment.

What I didn't love was being restricted to a desk, staring out a small window, and wishing I could be somewhere else. I have always liked to be on the go, and although I rarely sat for too long, it was being confined to a building, day in and day out, that made me weary. Lunch was always a welcomed break. Most days I left to eat lunch, even if it was just a bag lunch in my car. I wanted to get out. I couldn't afford to eat out, but I needed to at least feel free for that short break. Eating a sack lunch in your car isn't very glamorous, but it gave me an interesting perspective, a realization that I didn't like. It was in that car, pondering the work waiting for me inside, that I realized, no matter how well I did

my job, I would never make more in my position. I was great at my job, my boss loved me, and my patients loved me, but there was no growth opportunity. I could be the best nurse or the worst nurse, but I was going to make the same. It was a sinking feeling.

Michael was stuck in a similar situation. He liked working as an engineer in the military—the mission, the camaraderie, the people. But he didn't like being told what to do and where to live. And no matter how good a job he did, he also got paid the same. As a first lieutenant, he earned $31,000 a year. Similar to me, he knew that he could be the best or the worst lieutenant in the Air Force and he would make the same as everyone else. He also wanted to be in more control of his career and his income. We had bought a little one-and-a-half story house on the outskirts of Dayton. Within a month of settling in, a shooting, a murder, and a car arson on our street told us we should look for a different place to raise a family. We decided Bellbrook was the right area for us and dreamed of building a home there one day.

While we endured the status quo, Michael went back to school to get his MBA. He reminded me that I'd always wanted to work in television. Why not go back to school for communications? Education was important to my family. My dad was an educator with a master's degree, and my mom went to business school to become an administrative assistant. When I was a fresh high school grad, my parents had discouraged me from anything having to do with radio and TV. Growing up, my dad would say, "Jessica, you have a face for radio," and I believed him. But now, what did I have to lose?

I went all in. While working in nursing, I took night classes to earn a bachelor's degree in communications, and I finished with a 4.0 GPA. I parlayed those grades into an internship at WHIO-TV Channel 7, our local CBS affiliate. Michael told me I would be their superstar. Far from it—it went horribly. The newsroom chewed me up and spit me out every day. I was known as Intern One. I hated to hear one of the newscasters yell, "Who is Intern One?" I so badly wanted to raise my hand and say, "It's me, the same girl you yelled at yesterday. The same girl who had

grammatical errors yesterday, the same girl who wrote the story the way I saw it and you changed it yesterday. I'm still here. I know it's crazy that I've stuck around, and I can see why you might think a new intern could have started under my fabulous title of Intern One, but it turns out that it's still me. How can I help you?" But instead, I responded quietly and tried every way possible to learn and to get better at this godforsaken job. The media industry isn't simply a stab-you-in-the-back business, it's in-your-face cutthroat. Plus, I have an accent. Back then I had a thick southern accent. It made me a great target for the other interns and for a few of the reporters who didn't want to see me succeed. But I kept showing up. I was determined to give this my best shot. I wanted to do well at it. I was relieved at the end of the internship that it was over, but I was torn because now I had this degree and I wasn't going to have a job to show for it. It was a frustrating time in my life.

Thankfully, there was a shining light in all this. Dr. Sherry Wheaton was the health reporter at the time. She took a liking to me, and when she was there, she would request that I work with her. She taught me a great deal, and I loved that part of the job. To be fair to this particular organization, although I didn't think it was the best training in town and I felt beat up after every shift, I also recognize I wasn't very good at the job, and under these circumstances, I didn't see myself thriving. Still, I thought working in television was what I wanted to do, and when WHIO didn't offer me a position, I started looking around.

Underqualified and fully expecting to be told no, I applied for a position at the local PBS station.

In my interview, the general manager asked me, "What is one of your biggest weaknesses?"

"Chocolate," I said.

We both laughed. Our rapport resulted in a formal offer. The salary was lower than I hoped for, and I'm usually the girl who says, "Sure, no problem!" But Michael urged me to ask for more. I hardly felt qualified for the job in the first place. Still, I went back to the general manager and told him what I wanted.

"I'd really love to take this position, but at the current offer, I don't feel like I can accept it based on the expenses of working downtown."

The GM asked what it would take for me to accept and matched the number I wanted. I finally felt like the superstar Michael told me I was. I did voice-overs for ThinkTV programs and ran the annual auction to support the network. At twenty-five years old, I managed twelve hundred volunteers for the live auction and met our fundraising goal.

Throughout my ThinkTV tenure, I never reported to that general manager who liked me. My boss was a production manager who had held the position before me. She had been very successful in the role and had her own ideas about how things should be done. Although I like to think I'm a quick study, I wasn't quick enough for her. I could tell I frustrated her every day. I mean, it was obvious when she said, "This is very frustrating. You just secured a donation that is half of what I secured last year. What are you saying on the phone?" I was following the script given to me, but that didn't seem to be the right answer either. I just kept showing up. I wanted to quit every day, but I also wanted to complete the project I had been hired for. Let's just say that we were both happy when I resigned at the end of the auction season.

So after a good college try in television, I decided to chalk it up to a great experience and move in a different direction. Little did I know how much that job experience would help me later in life. I'm so thankful I pursued what seemed to be a dead-end road. It was a great lesson in always putting your best foot forward. You never know what you will take from one experience that will help you with another.

Once I decided to move on from television, that's when I landed a job in Big Pharma, and I thought I was sittin' pretty. Back in those days, the compensation package was sweet. I got a free car. It was a Ford Taurus and it might have been maroon, but read that word again—*free*! We were in heaven. I also got an expense account. In addition, in those days you could treat doctors to dinners out to discuss products and learn more about what they needed in their practices. Goodness, I wish I had the time to tell you about the night a doctor went completely overboard on the company dime and I was convinced I was going to get fired. Thank-

fully, my boss liked me and trusted me to do the right thing. I learned a big lesson that night. I was so green in that business; there was so much about it that I loved—and also hated. The industry changed a lot over the years, and at one point I felt like a glorified caterer, delivering meals to offices just to score a ten-minute chat with the doctor. It was maddening. I didn't feel like I was using my brain, and I even had one doctor say as much. The pay was so good, I didn't think I would ever be able to quit. When we had our first child, I decided the grind of travel and the mundane task of waiting for a signature was more than I could take. Michael and I had a lot of tough conversations. All of them ended with me staying in the position I no longer enjoyed. We had grown accustomed to my earnings and benefits, and letting that go seemed crazy. Earlier I mentioned the health scare with our son; sadly, that's what it took for me to make a change and move toward what I thought was my dream job. I was finally a stay-at-home mom. The problem was, I hated it. Am I allowed to admit that? I love my kids, but I also love to work. I love to build and grow. I needed to use my mind differently.

It didn't take me long to realize that I was not cut out for the toughest job in the world. So as quickly as I could, I headed back to corporate America. My next job was as a sales rep for a medical laser company. Did you know that selling laser services is a thing? I didn't. The main reason I took the job was for their health-care benefits. The company didn't pay much, but they did offer health care, which we needed because we didn't have any; I was pregnant with Kyle, and Michael was basically self-employed with a start-up. Eventually the laser company decided to sell, and I was going to find myself back in my dream job as a stay-at-home mom. At first I embraced it. I had two little boys, and I appreciated the freedom to be home and take care of them, but eventually my desire to work came creeping back in. Remember the boss I had at the TV station, the one I frustrated at every turn? Well, oddly enough, the relationship was salvaged, and she talked me into doing a live thirty-minute health show. Producing, writing, editing, presenting, everything. It was me on-air and me in the editing room with the camera guy. To produce each episode, I had to come up with B-roll and find

experts to interview. I brought my crew to on-site interviews, came back to the office, put the segment together, went live on TV, and took callers on the show. Nobody tells you how stressful it is to think on your feet when you're on live TV and when you have no idea what a caller might ask or say. It was so bad; *I* was so bad. Somehow I kept the job long enough to complete two seasons. Looking at it now, I crack up. How in the world did they let me do two seasons of a live TV show? Are y'all reading that—it was a *live* show! I mean, what could possibly go wrong thinking off the top of my head, using southern slang and sayings that my guest might not even understand, and trying to fill time when no one was calling in? It was dreadful.

From health care to television to pharmaceuticals and back to TV I went. By that point, my experience stack had grown. I had multiple college degrees, live TV experience, and sales training from one of the top pharmaceutical companies in the world. I had also started and failed at a few entrepreneurial ideas along the way. Still, after motherhood, I didn't know what was next. That's when the next thing found me.

During a trip to Chicago to see the *Oprah Winfrey Show*, Michael planned a dinner out with a business associate and his girlfriend. She was so Chicago; very shabby chic, with an artist vibe and an air of sophistication that was intoxicating. If we had been in Ohio and there had been the risk that we might have to see them again, I would have probably been intimidated by her, but for some reason, I enjoyed the evening just being myself. She shared a business idea that she was working on, and I had a blast brainstorming with her. During dinner she said, "I wish you lived in Chicago so that we could do this business together." Well, I had no interest in doing the business; it was the newborn photography business I shared earlier.

After we left dinner, Michael said, "Jessica, you should do this with her." Was he crazy? I immediately went into defensive mode. First, Michael had never gotten excited about a business idea of mine. Now he was giving me permission to pursue something that I knew zero about. I wanted to start a business, but it would have been nice to at least know more than absolutely nothing about it. I hemmed and hawed for weeks.

I told you about my many bold statements of all the things I would never do (edit, upload, download, etc.). The old saying never say never hit me smack in the face when I found myself doing all those things. That's what you do when you're an entrepreneur. You do whatever needs to get done.

So you see, there was nothing special about me. I didn't start a photography business after earning a prestigious degree from a fine arts school. No, I took an idea and I ran with it. I was willing to make mistakes, learn from them, and keep going. Was it hard? Absolutely. Was it worth it? You bet it was. Michael was laid off shortly after we got our first contract, and all of a sudden, I needed to figure out how I was going to provide for my family. Feeding three small children and covering the mortgage is quite motivating. (Yes, we added a little one in the first seven months of that business. I didn't know I was pregnant until after we signed on the dotted line. I might not have been so brave if I knew my Quincy was on the way.) When Michael lost his job, it was scary. I could have gone back to corporate America. That would have been the fastest way to earn a check, and plenty of people told me I should, but I knew I needed to take a chance on me. By doing so, I was able to set my family up to live life on our terms.

It wasn't all rainbows and roses. It was more like fourteen-hour days in a tiny home office around a baby's schedule and a lot of rejection. It was printing brochures on fancier paper than I could afford, only to find a typo. It was burning CDs to take to the hospital and sell the next day, as I was the daily photographer for the first six months in business. Just me. I was the photographer, marketing department, shipping department, complaints department—you name it, I did it. I can't tell you how many orders I took driving down I-75, trying to pull off the road so that the caller had no idea we were a mobile customer service department.

In my first month in business, I faced a huge disappointment that could have derailed me. It just so happened that our neighbor was a maternity nurse in a large hospital. When I saw her sitting on her front porch one day, I went over and told her about the new business venture. Our kids played together often, and she knew me well. I assumed

that she would be excited and hoped she would offer to introduce me to her manager.

"You're wasting your time," she said. "Everybody has a phone or a digital camera. No one would pay for that."

I was crushed. I was stunned. I went home and told Michael what she said, informing him that we were dead in the water and that we would probably need to throw in the towel and head in a new direction. He loves my ability to blow things out of proportion.

"That's just one hospital," he said. "It's still a million-dollar business idea." Bless his sweet heart, did he not just hear that the one and only connection I had said it was a terrible idea?

OK, give me just a minute. I needed just a minute to catch my breath. I went to bed that night, and I did what I like to do: I prayed about it. I got up the next morning feeling refreshed and renewed, and I went to work. I picked myself up and thought of ways to meet other nurses. I got on the computer and googled neonatal and obstetrics conventions near me. I knew from pharmaceutical sales that it would be better to get a hundred noes in one day than a hundred noes over a hundred days. I found a conference and signed up. Just as I'd set up my little booth, nurses started approaching.

This first conference proved to be a game changer. Long story short, a well-connected nurse named Pam Stout was very impressed with what I had to offer. She helped connect me to her nurse manager, and I had my first contract a few short weeks later.

With thirteen days before our official start date, the hospital called and said their top obstetrician's son was born that morning and they wanted pictures.

"I know you're not starting for two weeks, but is there any way you can come photograph his baby?"

"I'll be there in the morning," I said. Remember how I mentioned I used to say yes to everything?

I hung up and thought, *What did I just agree to?* I had barely photographed a live baby! My partner had trained me with a doll, I had practiced on two friends, and now I was going to walk in this hospital like I

knew what I was doing? Plus, it was their top OB in the room? What in the world was I thinking?

My thoughts were frenzied. *What am I supposed to do? I have to show up and photograph this doctor's baby! There's no way I can line up a freelance photographer to come with me on such short notice. What if he hates the photos? He'll cancel our contract.*

I called my business partner in Chicago, hoping she would say that she was going to jump in the car and come do it. But she didn't say that.

She told me to get a hold of myself, take a deep breath, get my camera out, and practice. That is exactly what I did. She had trained me and was confident in what she had taught me, but I felt like I forgot everything she told me.

So, as it seems to go, I went to bed praying, the sun came up, and I was expected to be at the hospital around nine o'clock that morning. I packed up my camera and away I went. I called my partner on the way, and she gave me a photography lesson over the phone. When I walked into the maternity ward, the obstetrician's Hispanic mother-in-law pulled me aside, fretting.

"I'm worried about this," she said. "About the baby. I will not let you unwrap him. He is going to get cold. He is going to get hiccups. This is so awful for him. I do not know why they are doing this to him."

I told her I was a professional—true, technically—and that I had a health-care background. That didn't stop her from shadowing me. When I went into mom and baby's room, the obstetrician thanked me for coming. They were too tired to ask grandma to back off, so throughout the photography session, I had a little helper—standing so close her shoulder pressed into my back. I got maybe three adequate pictures when she stuck a pacifier in the baby's mouth and whisked him away. What should have taken twenty minutes took well over an hour.

I called Michael on the drive home.

"It was horrible. As soon as they see these pictures, they're going to cancel the contract."

When I got home, I connected my camera to the computer. I'd already gotten this far. Why not keep going? I figured it would take more

time to hire someone to download, edit, and send the photos to the obstetrician than to do it all myself. So I did.

A day later, the doctor called.

"I love them!"

To date, his order is still the single largest order I have ever sold. One print he wanted was a large forty-by-thirty-inch canvas.

All righty then. I guess I'm a photographer now.

For the next season of life, I drove to the hospital's maternity ward six days a week, every week. Every free moment not spent with my kids, I was staring at the computer, editing, uploading, and placing orders.

All this coincided with my next pregnancy, our daughter, Quincy. Everything is a bigger deal when you're pregnant. I remember especially well the day the hospital scheduled our first demise photoshoot. That's when the baby passes away in utero or in childbirth, and the parents want posthumous photos taken. I knew nothing about what to expect beyond the obvious—these moms needed to be nurtured. It might seem odd if you don't understand it, but it's a powerful gift for these families. It's the only tangible thing they leave the hospital with, and it's the best way to honor their child.

Before I left the maternity ward that day, I asked to see my baby on the monitor. I needed to hear her heartbeat. Handling a baby who didn't make it knowing full well that this little person could have been my child . . . my heart was broken for that family. Everything was fine with my unborn child, but I still headed home shaken.

I presented the photos I took that day to the parents at no cost. It's our company's gift to the bereaved family. To this day, we volunteer our services to families enduring the loss of their babies in hospitals across the country.

When Quincy was born a couple of months later, I finally hired the freelance photographers I'd intended to from the beginning. Through partnering with others like me, the company expanded beyond Chicagoland and southwest Ohio. Around the eight-month mark of business, Michael joined as an official partner; prior to that he was the world's greatest volunteer. At the pace we were going, we could easily replace

his salary so that neither of us would have to return to corporate America. We would grow this thing together, traveling around the country to hospitals, conferences, and trade shows as a family.

The downside was the rigorous schedule. I would come home at six o'clock, have dinner, play with the kids, put them to bed, and get back to work at eight thirty. I'd work past midnight, often until two or three in the morning.

Michael told me he gained a new respect for me when he saw me in my work environment. Most husbands don't get to see that. To work alongside your spouse is to see them from a different perspective. The first time Michael joined me for a sales appointment, I was running a meeting with a hospital board, the CEO, the nurse manager, and the VP of nursing. He took notes. I looked at him once for affirmation, but he stared back with a dumb look on his face. Almost like he was surprised at what I'd said. *Had I said something stupid or made a promise we couldn't deliver on?* When we left the hospital and headed for the parking garage, I was going to ask him about it, but he beat me to it.

"Jessica, that was amazing. I just sat there in awe, watching you command those bigwigs and run the show. I knew you were good at sales, but to see you actually doing it . . . wow."

"I'm just doing my job." I smiled. "That's the way I always run meetings. I was wondering why you had such a dumb look on your face. I didn't know you were just admiring my work."

As every entrepreneur knows, there comes a point when the business grows beyond your ability to manage it. I realized we'd reached that point when I met a nurse manager from Portland, Maine, at a national nurse's conference who asked us to visit her hospital. I asked Michael what he thought. It turned out he'd spent a summer working at a sailing resort as a kid and was excited about the prospect of growing in another state. All in! Now we had to figure out how to build a remote business. How do you hire, train, and manage people who are a plane ride away? How do you keep the same quality in a different location? As with every previous job, I had no idea what I was doing. But all that past experience proved that I could figure it out. And I did. We rented an apartment in

Portland for a few months so we could more easily travel back and forth. The first thing we did was publish a job posting on Craigslist and host interviews at a hotel. People came in wondering if we were a scam, but we looked comically normal. And also out of place. I wish I'd known how much snow Maine gets in February. By summer, I longed for the South. The Portland model worked, so we knew we could expand and scale without Michael and me having to be on-site. We took the business to South Carolina, Georgia, and Tennessee while other partners began working in other states. Prior to building up business in those states, I had to travel in person for the contract meetings with each hospital and train all photographers in person. I was traveling to hospitals in multiple states and was often there for several days to meet with nurses, train staff, and manage expectations. I loved to travel and I loved working, but I was exhausted, and the most challenging part was managing people.

I had to fire one of my first employees because she wasn't doing a good job while getting paid too much. Michael said he was willing to have the conversation with her, and I said I'd rather talk to her personally. I drove about an hour north of Dayton to meet with her. Our sit-down took longer than expected. When I got back in the car, I called Michael, crying.

"She's going to be OK," he said. "Her husband has a great job. They have a good income."

"That's not it, Michael," I said. "I just couldn't bring myself to fire her."

"Are you kidding? We know this needs to happen."

"I haven't told you the worst part yet."

"How could it be worse?"

"I gave her a title, a promotion, and a pay raise!"

"What?"

"I just can't fire people. I'm sorry! You're right—you have to do this."

From that moment on, Michael took over managing all employees. He wanted his first assignment on the job to be to fire that employee, but I wouldn't let him. For another three years!

With Michael managing everyone, I finally got a break from the day-to-day operations. I was still pitching hospitals and working to get new contracts. The pace of the job had caught up to me. I was tired. Tired of the grind, tired of the travel. One day I lost track of time scrolling social media and saw a before-and-after picture of a friend in California who had a similar skin condition that I was frustrated with. I had been going to a local dermatologist and spending a fortune on what he called the number one product. I had about twelve bottles that I was using between my morning and night routine. I was getting facials and weekly microdermabrasions. I was doing it all. I was working hard to take care of my skin, but I wasn't seeing any real improvements.

I kept looking at that before-and-after photo and thinking, *I'm not getting results like that*. I sent my friend a note. Whatever that wrinkle cream is, I need it. She asked me to jump on a phone call with her and her business partner, and I agreed. They told me about the products, answered all my questions, and suggested I consider becoming an independent consultant for their direct marketing brand. I thanked them but wasn't interested.

"If you ever change your mind, there are a couple of things I would love for you to know," my friend said.

She told me several things, but all I heard was "deepest discount," and I signed up that day.

Immediately I had regrets. What did I just agree to? The good news was that I hadn't agreed to anything except getting great skincare at a great discount. The kit arrived, and I was excited to try it. Within two weeks of using the products, people started asking me about my skin. No one was asking me for skincare recommendations when I was spending a fortune at the dermatology office. It was so exciting to start seeing great results.

One girlfriend asked, "Jessica, did you change your makeup?"

I said, "Friend, I've been doing my make up the same since 1989. The only thing I've changed is my skincare." I was so excited to share with everyone. But I didn't want to be one of those girls. You know, the ones you dread to see coming. They put you on the spot and ask you to

host a party. I don't like that, and I didn't want to do that to other people. For me, I just wanted to be Jessica who happened to sell skincare. I wasn't going to slather your face with cream and beg you to buy anything. What I found was that as I enjoyed the products, it was easy to share what I loved about them. Friends and family started asking me for more information, and the business started to grow.

In my photography business, we poured everything back into it. It took three years to build up enough consistent revenue that we could take a salary. But the skincare opportunity brought cash flowing within the first few months, not years.

"I think I can make a business out of this," I told Michael. "I'd like to make fifteen hundred dollars. That at least pays for the kit and then some. But whatever profit we do make, I want to give it away to charity."

I knew my cousin wanted to take a mission trip, and I wanted to support it. We could have supported it from our regular income, but something about this business had me dreaming about giving in a bigger and bolder way. Initially, Michael thought it was a cute idea. I think he expected me to make a couple of hundred bucks. As long as I was covering what I was using, he was fine with me giving the rest away.

So again, I decided to pray about it. After much consideration, we decided I would do the business for a year, and we would donate my profits. I was excited to give it my best shot. The business took off faster than we could have imagined. Truly, God blessed this business in ways we didn't see coming. Don't get me wrong, I worked hard. As with anything, God didn't just drop a paycheck in my lap; I had to consistently work. It's a simple business model, but it requires hard work and dedication. I was excited about the opportunity, and I was confident in the brand and the products. It started by posting before-and-after pictures on social media and replying to comments and questions like "What product are you using, and where can I buy some?" By the end of my first year, I was one of the top team builders in the company. Yet I'd worked the business for only six months. I was the first consultant from

Ohio to earn a Lexus for sales and recruiting. I ended up walking with the company CEO on a gorgeous beach in Thailand for the annual top achievers' celebratory retreat.

"I graduated from the Ohio State University," she told me. "I've watched for Ohio to show up on the company radar for years. One day, there was a little tiny dot of growing business. Jessica Bettencourt in Dayton, Ohio. I thought for sure Columbus, Cincinnati, or Cleveland would put us on the map in Ohio."

"Nope! Dayton, and I'm having so much fun," I said, probably coming off like a complete idiot. At least my sales numbers spoke for themselves.

Building the skincare business also involved supporting others who were starting theirs. The products and the opportunity are both amazing, so why wouldn't people do it? When I told my story, they realized I didn't need their money, so there must be something to it. My real joy has been watching women earn an extra $500 to $1,500 a month, even more in some cases. Success is different for everyone, and an extra $500 can help a family make ends meet. For others, it's fun money for massages, fine dining, and family vacations. For a few, the business has replaced their income and given them new options.

Coaching women at every stage has made me feel like a whole new person. I went from exhaustion to passion. I helped people's skin *and* their savings every day. Meanwhile, in our other business, we were providing photographers who love babies an opportunity to get paid for what they enjoy—and get paid a lot more than what other family photographers are used to making in that industry based on having consistent daily customers. Everything about that feels good. Two very distinct business models, both great for different reasons.

I learned a lot in both businesses, and many things that I learned in one, I could apply to the other. I didn't expect so much professional growth after starting the skincare business, but it was a big bonus.

WHAT BABIES, BUSINESSES, AND BIBLE STUDIES TEACH US ABOUT THE FUTURE

What does a winding career into social media entrepreneurship have to do with accomplishing my dreams? A lot, actually. For every new opportunity I seized, I was not qualified for it on paper. But I had self-qualified. I wasn't starting from scratch; I was pulling from my talent stack. I was using past experiences to work in new endeavors. Even though I had no professional photography experience, I had qualifying experience caring for babies (my own), selling services, and working in a clinical setting. I trusted that I could learn the rest. And even though I didn't feel qualified for direct sales, my health-care background, my experience with an inferior skincare solution, and my passion for empowering women qualified me. So yes, I was qualified for my dreams, and you're qualified for yours, too. Own them. And do something with them. Be different from the majority, who get tunnel vision. Did you know men will apply for a job they only feel 60 percent qualified for or matched with based on the job description? Women want to be fully qualified. We are robbing ourselves of so many opportunities. Most women think that to do a specific job, they need a particular education or skill set. The truth is, you are probably better qualified than you realize. There is something you can pull from your college experience, your family roles, that one company training you took, the crummy volunteer work you feel guilty about wanting to quit, or the first job you had (and hated). More than anything, you've already proven you are capable of learning what you need to know to get the job done. There is no wife or mother school, yet you're probably both. Who qualified you to embrace those roles if not you? And without even knowing you, I can almost guarantee you are doing a better job than you think.

Consider how many qualifications you already have but aren't rec-

ognizing. The aspiring skincare entrepreneurs I talk to day in and day out who find me through a training or a speech I've given tell me, "Jessica, I'm a terrible public speaker." When I ask if they've ever done public speaking, they say no. Yet they teach a women's Bible study or they are the president of the PTO. That's public speaking. They're there to lead the conversation, and that's all public speaking is. It's a long, one-sided conversation between you and the audience. Sometimes it's more interactive. Chances are you can find a formula that works for you. Ladies, we must stop disqualifying ourselves for what God has already qualified us for through the lives he's called us to live. Far be it for any man or woman (you included!) to tell you that you have no business in the business you're meant to be in.

Showing up doesn't mean you'll do so perfectly. The first day of my drug rep job, I tore off a truck mirror while parking, locked myself out of the car, and broke the heel of my shoe. All while my new boss was with me. At least he apologized for laughing at "the funniest sequence of events in pharmaceutical sales history," as he put it.

I walked into many different, uncomfortable experiences having no idea what I was doing. I can't count the times I felt completely unqualified to be in the room. Yet I always expected to win. I decided to be confident, and I took a mindset of *yes I can*. I was willing to figure it out. I decided that the pain of learning new things was less than the pain of being stuck in a position that I didn't enjoy. I didn't always come out on top, but a win for me was learning something that day. A win for me was surviving. I trusted my God-given talents. I trusted the ability to learn, and I prayed a lot. I simply knew that I would make it. I expected people would like me. I expected to learn and do whatever it would take to move forward.

If you see yourself as always learning, you'll be able to draw from every experience and use that lesson in the future. Because no matter what happens, chances are you can figure it out. You're certainly qualified to.

CHAPTER 9

Objections Are Opportunities

And we know that for those who love God all things work together for good, for those who are called according to his purpose.

—*Romans 8:28 (ESV)*

I was a cheerleader in high school. I was born into a very athletic family. I don't have an athletic bone in my body, but I'm a great athletic supporter. OK, that is so juvenile, but it made me laugh. As a cheerleader, you have to be a team player; you have to want what is best for the entire team. I was fortunate to be on a highly competitive team; we won several regional competitions and got invited to nationals year after year. I loved being a cheerleader, and more than anything, I wanted to be a climber, the one who got to go to the top of the pyramid. There was one big problem with that: I was the tallest person on the squad. I was built like a base. Nothing I could do to change it, so I had to embrace it. Have you ever had someone stand on your shoulders over and over again to the point that they bled? The person up top gets all the glory while you're smiling on the outside and cringing in pain on the inside. But the pyramid couldn't happen without the base. No base and

you have a lot of girls standing around smiling. This is where I learned about helping others to help yourself. I wanted to win. I wanted our team to bring home the championship trophy. In order to do that, I had to be a great base for the rest of the pyramid to succeed.

If you want to succeed, help those around you be successful and you'll be successful, too. Inspiring, isn't it? Well, it's only half the story. Let me tell you a little something I've learned from a career in sales and as a mom, which is basically sales by a different name. Have you ever tried to get a toddler to eat their leafy green veggies? It's objection-handling 101. If you can overcome objections and help other people get over theirs, you will both reach your goal. The problem is that you can't pull a mule up a mountain it doesn't want to climb.

In life, how often do we try to pull mules? How often do we assume other people want what we do and for the same reasons? The same health goals? The same marriage satisfaction? The same parenting outcomes? The same income and lifestyle? Even the same relationship with the Lord?

It's not as simple as all those motivational quotes make it sound. Yes, you can have just about everything you want if you help others reach what they want. The reason it's so difficult to cash in on this sentiment is that it's stinkin' hard to help other people get past the objections they have to whatever they want. It sounds crazy, but I encounter it every day when I'm talking to women all around the country about their personal, financial, and spiritual goals. It breaks my heart that so many women tell themselves they'll never be able to earn what a little elbow grease and a lot of time would otherwise bring them. *A lot of time* doesn't mean decades, by the way. As I built both my businesses, I was willing to make big sacrifices for three to five years rather than trade time for money for the next thirty to fifty years. The standard American dream didn't sound dreamy to this chick. I get that not everyone is willing to do what I did. And that's OK. The problem is that no woman is an island. I could not achieve my goal to grow a multimillion-dollar photography business without many people—hospital CEOs, nurse managers, photographers, new parents, and on and on—also achieving

their goals. That looked different for each person, but I still had to obey the rule. Want what I want? Help other people get what they want.

You're probably realizing how this rule permeates all areas of life. To have a great spouse, you must be a great spouse. To raise responsible kids, you must teach them to be responsible with their bedrooms, their toys, and their friends—you know, the things they want in life. You can think of a hundred other ways this applies to you. The hard part is encouraging others to overcome their own objections and mental blocks when it comes to what you're helping them with. In other words, other people's obstacles are your obstacles.

I'm a little confused just writing that, so I'm going to teach you how to get what you want out of life through my experience in direct sales. The industry is still on our minds from the last chapter, and besides, direct sales is a metaphor for life. To build a big business, I've got to help other women build theirs. I can overcome obstacles that stand between me and my dreams, but if I don't also help women on my team, I'm not going anywhere.

Even if you're not in a business like mine and have no desire to be, there's still much to gain from this chapter. Simply map these principles onto the area of life where you're struggling to see your desires come to pass. These work anywhere. For example, if you have a weight-loss goal, you need to prepare nutritious, balanced meals. Which means you also have to convince your spouse and kids to eat those meals. What are their health and fitness goals? How does getting what you want help them get what they want and vice versa? What about your faith walk? Maybe going deeper with God means leading a women's Bible study group, which by design involves you studying more and helping others on their journey, too. Or you'd like to earn some extra income. OK, how? By adding value to others. Through your business, empower others to earn what they want. Maybe you want to change career paths or go back to school, but you can't see how to make this work with your family. Help them see how sacrificing now will benefit them later. Too often we set our plans, ideas, and dreams aside because we worry about how it's going to affect our family in the short term. Perhaps we

don't want them to make sacrifices because it feels selfish. I want you to reconsider. Help them see that a short-term sacrifice has long-term potential and long-term gains for you and for the family. I would also argue that you are teaching your children a great life lesson by modeling the importance of showing up for one another; doing so will strengthen their bonds and encourage their independence. That's just a few of the benefits I see in my children as they had to make sacrifices for the betterment of the family. I won't give you my spiel, but I bet if you asked my children, they would all say, "That's the life of an entrepreneur's child." Again, there are hundreds of examples where this will benefit you, even if you never start your own business. Simply read and apply.

Let's do this.

Before we go any further, I want to share one of my biggest frustrations with women. I think by now we've established that I love helping women, but I have a huge pet peeve that I want to get out in the open. Here it is: Women disqualify themselves faster than a hot knife through butter. It drives me crazy! I don't care if you don't want to do the business I'm doing, but I care about what you want to do. But when you say you want to do something and immediately decide that you can't, I want to scream at you: you are right. you can't with that attitude! Now that I've got that off my chest, let's get to the real problem—or better yet, some solutions.

SHORTEN THE GAP BETWEEN HERE AND THERE

Women who hear about direct sales consultants who earn a six-figure income every year assume we're born with the ability and knowledge to do this business. That we have superpowers to get people to show up and join us. That couldn't be further from the truth.

No matter our skill set or business experience, when we start in direct sales (or teaching a class or opening a boutique), we all have the

same frustrations, the same disappointments, the same setbacks as the woman who's never sold anything in her life. It's how you handle those disappointments that will set you apart. High achievers in any industry have all been told no. A lot. The difference between quitters and achievers is who takes those noes personally. I look at every no as "maybe, but not right now." If you take feelings out of a business decision, you can weather the storm.

Early on in this business, I read a book that set me on course for success. I don't read much, and with rare exceptions, I never read self-help books, yet here I am authoring my own. Anyhow, I often can't get through the fourth chapter because I feel like it's stuff I already know. So I buy them, read chapters one through three, then look at the table of contents before skimming the last chapter. Thankfully, chapter three of a network marketing book said something I needed to know. "In the beginning, you will work a lot for a little. Eventually, you will work a little for a lot." Sounds pretty darn good to me. I'm not afraid of hard work. Especially if a big reward is attached. I don't need instant gratification.

After reading that line, my next thought was, *OK then. How do I shorten the gap? How do I go from working a lot for a little to working a little for a lot . . . in the fastest time possible?* For me, it was deciding I was going to do this business all in, not as a hobby but as a business. I was willing to make sacrifices now for long-term gain, and I was willing to be coachable. Stop and reread that sentence. Are you those things? If you said yes, you are coachable, that's awesome. But I'll ask bluntly: Are you really? Because that is probably the most important thing in any business if you want to remain sane. You don't need to reinvent the wheel. Most likely others have gone before you and have done what you need to do. You can learn from them if you are willing to. I didn't like what the leaders in my industry told me to do. I had two choices: do what the successful people were doing or figure out my own way. I decided to trust a proven system. I decided I would do it the way the successful people were doing it, and after learning their way, I would make improvements and add my style and ideas along the way.

You can apply this to any area of life. Look at parenting. Do you know parents who are getting it right? Whose kids do you enjoy being around? OK, those are the parents you want to learn from. Watch them, listen to them, take their advice. If you want to open a business, look at other businesses in the same industry and at other industries that you enjoy doing business with. What do you like about it? What are they doing well? What about the experience makes you want to be their client or customer? Learn from that and apply it to your idea.

There is a big mistake I see people make in direct sales that I also see in a lot of other areas, too. People want to know it all before they get started. They want to understand every aspect before they fully commit. I call this paralysis by analysis. Of course you need to make an educated decision, even though that is not necessarily what I did. I knew both businesses I started would lead to something, but I didn't necessarily know they would be as successful as they turned out to be. And if I had put that kind of up-front pressure on myself, I'm not sure I would have been willing to press go. I don't want to downplay the importance of an educated decision, but once you have done your research, asked your questions, and determined that you think this could be a good idea, then you have to decide to start. I know so many people (in direct sales and in other industries) who say to me, "I wish I would have started when I first thought about doing this business." I have a Realtor friend who first began researching and dreaming of becoming a Realtor ten years before she actually got her license. What took you so long, sister? Now, my faith would say that your timing is perfect, that God knew what you needed, but my human business brain says, "God would have honored that business ten years ago, too, if you were a good Realtor doing honest work and helping others get into a great house for their family." What's not God honoring about that? OK, all you back-row Baptists, settle down and stop clutching those pearls. Yes, I believe God's timing is always perfect, and I also believe he can take our messes and make them great. Now, if you have been one of those procrastinators, do you want to find yourself in this same spot five years from now? Perfect timing isn't a thing; making the best of your timing and seeing all the

good that comes with it is. God's perfect timing is him taking care of our messes. The gospel according to Jessica, Lord be near!

So, I did exactly what I would encourage you to do. I jumped in with just enough knowledge to know I could find the answers as I needed them. I was comfortable with the business ideas and the products I was representing. I would say it turned out to be a good way to get started. In my direct sales business, I ended my first year as one of the top ten recruiters for the company. I had not set that as a goal. I didn't have an income goal or a vision board. I didn't know how much I earned by recruiting someone to my team. I didn't understand the compensation plan, and I still don't. I simply did what more experienced consultants said to do. I didn't set out to be a top earner. I simply decided I wanted to give this my best shot. I was willing to learn as I earned, as we like to call it. I had never heard that phrase, but it worked in my photography business, too. You don't have to know it all; you just need to know enough to get started.

Here's a question you might ask yourself if you have considered starting a business but you are afraid of the time commitment, the learning curve, or the effect it will have on your family. "Why would you work harder for someone else than you work for yourself?" Let that sink in. Are you a great employee? Are you giving your job the best you have? What's left for your family? Have you considered the effect your job has on your family? Because we've been programmed to a nine-to-five mentality, we don't often think about or see the sacrifices the entire family is making when we leave for that corporate job. There are sacrifices, expenses, and learning curves in anything you do. I loved my jobs in corporate America, and I was good at them, too. But I was trading time for money, and my family was getting my leftover energy, which wasn't much. I wanted to be an A+ employee for my business rather than an A+ employee for someone else when, if budget cuts came, I could be the first one they let go. Even in crummy jobs I've had, I enjoyed my boss counting on me to do great work. I loved being their right-hand man, and I loved being great in my position. Why would I work for someone else that way but not for myself? Consider that when you're tired and think

you don't have another ounce to give. Are you OK with giving your all to someone else but not to yourself? Don't you deserve your best?

I've shared a lot of my successes with you in this book, not to brag but to show you what's possible for anyone who follows what works and who puts in the time and energy. As with any job, there are going to be things you don't like, but it is different when those uncomfortable things are moving you toward your goal. As someone who posts a lot on social media now, let me tell you, I wasn't super comfortable doing so early on in my business. The leaders showed me the way, and reluctantly, I did it. I tweaked their formula a bit to feel more like me, and it turned out to be a great decision. I never wanted to host events either because it seemed way beyond my comfort zone, but gathering a large group was an efficient way to reach a lot of people. Again, uncomfortable but smart, so I did it. I wanted to shorten the gap between working a lot for a little and getting to work a little for a lot. I was smart enough to know not to reinvent an entire industry's best practices, so I did what the successful people were doing.

Here are some examples of other industries or interests that relate to direct sales. Are you a church planter? You are going to need to network in your town. Are you a real estate agent? You are a network marketer. Are you a salon owner or hairstylist? You are in the business of referrals and networking. Are you starting a support group for adoptive families? Welcome to networking 101. How about becoming a restaurant owner? Word-of-mouth referrals are your best friend. Do you want to open a ladies' boutique or an online jewelry business? Find a great network marketer, and they will have your store full in no time. Let me guess, you aren't a salesperson? Friend, we're all selling something. It's a matter of whether your selling is benefiting you or benefiting someone else. And only you get to decide who that's going to be.

I'm not going to get on a soapbox about direct sales (maybe you think I already have), but I have often seen entrepreneurial women put down direct sales because they make a lot of assumptions. One is that they think they need a huge network. They think they don't have one, so they go into a different industry. Guess what? You need a network in any industry, and if you don't have a big one, it's OK. I think it might even be

better. Many assumed that because I had my photography business that I had a big network. Quite the opposite. I had the tiniest network. My prayer group was my network. I didn't hang out at my kids' sports and music practices, and I didn't like volunteering in their classes. I sound like a terrible person, but the truth is, I love to work and take care of my family. When your focus and attention are geared toward a high-growth business and raising four children, it's hard to make time for much else. I became a private person by choice and by necessity. The two things I enjoy doing didn't provide a large network to pull from. I wasn't out there wanting to get to know every mom and make new friends all the time. Goodness, that does sound awful. I love people, don't get me wrong. But I don't like idle time or small talk. I enjoy working to grow something or putting effort toward something meaningful. Maybe you have a garden that takes a lot of time. Maybe you enjoy ladies' gatherings that take a lot of time. You must have priorities and use your time accordingly, but if it is growing a business, it will require you to narrow your focus at least for a while if you want it to be a success.

This brought me to a big obstacle in my skincare business. I was asked to host a skincare event in Dayton, and I said yes before I even thought about it. Of course I did. And then I wanted to die. I hate having parties and especially with zero people to put on the guest list. Who in the world was I going to invite? The midwives at the hospitals where we worked? Nope. Our photographers? Not appropriate. The heads of hospitals? Absolutely not.

I started out by looking at my close friends, then I expanded to acquaintances. I found that the more I thought about it, the bigger my network grew. I knew many more people than I realized.

Still, I wasn't giddy about putting myself out there. Scheduling events and posting them on social media felt like running through the middle school cafeteria naked but as an adult. The good news for me and my family? I'm willing to do things I don't like to do if it will bring me closer to my goals.

Here's what I discovered. I didn't die when I posted about my events or held them. More people were interested than I expected. The posts I

was making to social media helped more than I thought. That is how I grew my business. Talking to people, sharing what I loved, posting to social media, and hosting events I never wanted to host. I showed up and treated every event like there was no place I would rather be, and I treated each guest like they were the most important person in the room. At first the math overwhelmed me. But then I remembered my priority—to shorten the gap. Even though I didn't like it, I held a lot of events. Again, I know not everyone can do this, but you can do something.

My mentality was that I was going to talk to anyone who showed interest. Even if they never purchased from me, I wanted people to know what I was doing. It might not be for them, but what if they know someone who needs what I have to offer? So early in business, even with a very small knowledge base, I talked to everyone. Not in a desperate, spewing information kind of way but with confident excitement. Confident excitement! I didn't have a canned speech. I just had conversations. I didn't overthink how I was going to present this business, just like you wouldn't overthink it if your friend called and asked who does your hair. You might ask questions like "Are you looking for color or a cut?" and then you would tell them what you love about the salon you go to. This is a winning formula for anything you want to start—a business, a sports rec team, a moms' group. You need to get the word out: share with people what you are doing and connect with them.

I have a love-hate relationship with social media. It's great for so many things, but it can be a detriment, too. You have to put some good parameters in place if you want it to be an asset and not a hindrance. Social media made engaging with a lot of people easy. Another beautiful thing about it is having access to your network in far-reaching places. I'm an early riser. I don't necessarily love 4:00 a.m. wake-up calls, but by getting up super early, I can work with my Australian and Japanese partners. I know what you're thinking. *I'm not a morning person.* Well, neither was I, but with having small children at home, I taught myself how to become one. I added so many work hours to my week just by choosing to get up earlier. It was a sacrifice I was willing to make, and only you can decide what you're willing to give up. The most important part is that you have to make sacrifices.

HANDLE OBJECTIONS LIKE A BOSS

No matter what you choose to sacrifice, you will face obstacles, speed bumps, roadblocks. Pick your analogy. As you move forward, there will be unexpected delays. Even those that make you question whether this is worth it. Keep going anyway.

To get over those bumps, you may have to slow down and gauge how to proceed. Or you might plow right over them, get tousled a bit, and find yourself regrouping. But you're moving forward. You will likely learn a better approach, but nonetheless, you're moving ahead. The alternative is to see roadblocks as roadblocks. But even at a roadblock, we don't just sit there; we take another route. You might take a big, frustrating detour. You might consider just going home or even changing destinations. But think long and hard first. If you set out to accomplish a goal, expect to hit speed bumps. Even full roadblocks. If your goal is worth setting, it's also worth putting in the effort to get there. When any successful person looks back, they say it was the obstacles that taught them the most. Overcoming them often makes them prouder than the goal itself.

If you learn anything from my entrepreneurial adventures, it's that you, too, can overcome the fear of objections. Because they're opportunities. I also want you to come away knowing how to confidently address any objection. I want to help you recognize when an objection is a real concern rather than a smokescreen—when to let it go and when to continue the discussion. If you can get past the fear of objections, rejections, and negativity, anything you want in life becomes a lot more fun.

To show how an objection is an opportunity, I'm going to refer back to the direct sales industry. Again, this maps onto any industry or onto your personal life. People are people wherever you find them.

Network marketing is all about dialogue. I once sent a message to my dream team A-list that included the one mom who I knew that if she tried my products, every soccer mom in town would be clamoring to try them, too. But I got no response. It felt awful. I wanted to scream. I

wished she would just say something. The silence was killing me. I worried about what I would say when I saw her next. I wondered why I had sent the message in the first place. After going over it one hundred times in my brain, I laid it to rest. I did the right thing by sending the message.

No answer feels like rejection. No answer feels like a no. To make it in direct sales, I had to change how I received rejection—I had to go back to how I took noes as a drug sales rep. If the soccer mom didn't say no, if she didn't say anything, then that means it's a maybe. She didn't reply, so she must be thinking about it. Most importantly, I needed to realize she wasn't rejecting me. She didn't reply, "I don't like you, your big hair, or your shiny lip gloss, Jessica." Most often no answer is simply an objection that means "I'm not convinced this is something I need . . . at least not yet."

Here's a tip. Anytime you ask someone to do something for you or make a purchase from you, take your personal feelings out of it. Because it's not about you. Think of it as a waitress in a restaurant offering you another cup of coffee. You aren't offended that she offered it, and declining it has zero to do with the waitress. When someone says no to something you are offering, they aren't rejecting you; they're rejecting themselves. This is a true statement, but it's only true if you believe in the value of what you're offering to help them achieve their goals. If you believe yours is the best opportunity out there, represent it that way. Then the only feeling you should have when someone says no or says nothing at all is, *Wow . . . I hate that she is passing this up. She just doesn't get it.*

That's how I changed my mindset to take nothing personally. How do we move forward from there? What was I supposed to say when I saw the soccer mom on the field, at church, or in the grocery? "Hey, did you get my message about the world's greatest skincare in the United States? You would be crazy not to buy it! Can I sign you up right now?" No, and please never do that. That might seem extreme, but I've seen desperate pleas and heard verbal dumps.

Instead, the next time I saw this person, I engaged her the same way I always did. I chatted her up about everything except my business.

Normal, everyday conversation about anything but my beloved products. That might sound counterintuitive, but here's what I know. If I send a message to someone, don't hear back, then run into her at Target, I might ask her about her last vacation or about her kids. Inevitably, if I don't bring up my skincare business, she does. No one likes to be convinced, coerced, or guilted into anything. Whether you want them to buy your product, donate to your charity, or help you with a fundraiser at school, people need the space to be able to say no. You have to accept that no graciously. If I'm respectful, the soccer mom leaves feeling good. People are always more likely to be intrigued by whatever you're up to if you're not being pushy. You get them thinking about what you are doing differently. People want what they want, not what you push on them. People buy from confident people, not desperate people. If you believe in what you have to offer, just be confident in it.

Now, what if the soccer mom doesn't mention my message? No problem at all. I'll enjoy the conversation and find a reason to follow up with her that is not business related. Again, I don't bring it up. I want her to continue to see me as "just Jessica" who also happens to sell skincare. This allows her to feel no pressure and to watch my business from a different perspective; then, when she needs what I have to offer, she'll feel safe to reach out.

Up to this point, we've talked about what I like to call being the coy boy on the playground. You know the one. He's confident. He's not worried about anyone else on the playground, and he stays focused on the people willing to play his game. You want to be that guy, or better yet, that girl. We've talked about how to engage the nonresponders. Now, what about the responders? When offered an opportunity, few people ever say, "OK, sure. Let's do it." In my business, I receive ten common responses, ten reasons why it's a golden idea but "just won't work" for them. In your industry, there is probably a similar list.

1. "Not a salesperson."

2. "Not a skincare person."

3. "I don't know enough people."

4. "Everyone I know already sells it."

5. "I can't use social media."

6. "I don't have the money."

7. "I don't need the money."

8. "I use only all-natural products from my garden."

9. "I wash my hair on Sundays. I can't possibly add another thing to my week."

10. "I just don't get it."

OK, I don't hear the hair-washing excuse very often, but you get the point. You know the common objections given in your industry. It doesn't really matter what the objection is, but your response should be a clarifying question. Ask them to explain what they mean or what they need in their life. If you can figure out what they need, you can offer a solution. If you can help them see your solution, you can help them overcome their objections. That formula will help you with any objection you may encounter for anything else you want in life. Here's my best advice. Think about the most common objections you are hearing and then practice your answers. Out loud. Get good at smoothly addressing them so that you don't come across defensive or caught off guard. To this day, I still practice what I say before a meeting or a phone call with a potential business partner.

I don't want you to overlook this tip. Practice out loud. I know you are going to feel silly; I did, too, but at least you only feel silly in front of yourself. Your gut is going to have you do this half-heartedly, and by that I mean you are going to want to practice just in your head. Resist this. Practicing out loud gives you the opportunity to hear how you sound, to self-correct, and to feel confident about your answers.

People who need this objection-handling practice the most are those who dread the worst-case scenario. What if they say no? What if they try to block me on social media? What if they're going to leave me a one-star review? What if they report me to the Better Business Bureau and I go to prison? I won't be able to get my eye cream in prison!

What objection scares you the most? Why? Think it through and figure out why that fear is not true and not as scary as you think. If you ask yourself some questions and then do a role-play, you will begin to realize the very thing that seems awful is not that bad. Record yourself in this role-play. It's not enough just to think; you have to speak, because when you hear yourself responding to the hypothetical worst-case objections, it's not scary. In fact, it calms the fear. You hear how silly your worries sound and how easy it is to say what you want to say. When you're just thinking, you're a jumbled mess, like a junk drawer where you have to dive past all the wrong words to find the right ones.

After all, what's the worst that could happen? Someone unfriends you on social media, most likely. That says more about them than you anyway. If you're asking somebody to be a part of something you're excited about, if you're asking someone to try a product you love or to volunteer at the school fair, if you're asking somebody to go to a play with you or to be a workout partner, whatever it is you're afraid to ask somebody to be a part of, why in the world would that be offensive?

Think about the way you like to be approached. Whatever medium you use to engage the people whose future matters to yours and vice versa, have real conversations. Think about what a conversation is. Who do you enjoy having conversations with? Someone who asks questions, listens, and also shares. Not someone who talks the entire time you're together and never lets you get a word in edgewise. It's not someone argumentative, defensive, or salesy. People enjoy talking about themselves. Let them. Eventually they'll get around to asking you a question so that you can share, too.

Conversation is asking questions, listening to the other person's answers, and responding to their questions. It's so much fun when you do it right. I find in North American culture that there are three common questions people ask. Where are you from? Do you have children? Do you work outside the home/what do you do for a living? You can decide what information you want to give. When it feels right to steer toward what I do for work, I drop that I'm in the antiaging business.

"Did you say antiaging?"

It happens almost every time. They might talk about themselves, but

inevitably they come back to what I said. You can do the same by thinking of a quick, easy, but interesting explanation of what you do or what you are excited about. Then, when someone asks, be ready to say what you want them to be intrigued about. Try it. I bet they'll ask a question. When they do, they're giving you the green light to share a little more. The key to success here is the *little more* part. You don't want to go into a monologue about your latest venture. Let me be transparent. I was guilty of a verbal dump to my number one prospect in my first year of business. To correct it, I was honest with her. I apologized, made light of it, and hoped she would show me grace. I said something like, "Hey, when we talked last week, I think I scared the daylights out of you. I got so overzealous about this new business, I'm not sure I let you say a word. I'm really sorry about that. If you're willing to give me another shot, I promise I won't tie you down and wash your face in the middle of the grocery store."

She laughed, I laughed, we chatted again, and she bought. Often it just works out that way. If for whatever reason it doesn't, that is not cause to get defensive. You're just having a conversation, remember? The best way to keep from getting defensive is to ask a clarifying question. Then listen to the answer. I've found that people often can't explain why they think what they do and they talk themselves out of the concern. That's what I call a smokescreen. They don't know what their true concern is, so they just say something—anything. Or they may have a real concern but can't pinpoint it. By getting past the smokescreen, you have a better chance of hearing the true objection.

So share, ask questions, and listen. Don't go into lecture mode and explain why their objections are wrong. Talk about how you can relate to their concern; tell a story to prove it. Let them see themselves in the scenario. They have to see how their personality fits into the picture and how they are going to benefit. People want to know what's in it for them. A great tool to help someone relate is to share a story. If they can relate to your story, share it. If they can't, share a story of someone they can see themselves in.

This applies to any industry. If you want to get volunteers for the

book fair at school, help them see how it will benefit both their child and the school. If you want to add an influencer to your brand, help them see how their network will grow, too. You must focus not on what you need from them but on how it most benefits them. If you listen to the other person, you'll quickly learn what is important. "Sell to the need," as my friend Carrie taught me.

What about those who have one million objections? We all know those people who can argue about anything and who seem to enjoy doing it. I call these people Aunt Sallies. They would be great in your industry, but they just can't get out of their own way. Not everyone is meant for your opportunity, your goal, your dream. Some people you have to let go. When you do, some come back. The only way this happens is if you continue to grow and show them something they want to be a part of. Hovering over them, trying to convince them, or waiting until they get it won't work because you aren't showing them anything they would want to be a part of. If you fizzle out, you prove them right. If you ignore them at family functions or the soccer field, you convince them they were right. Who wants to be a part of that? So graciously let Aunt Sallie say no. It's hard, I know. You may beat yourself up afterward. You may think of the perfect question you could have asked that would have hooked her, but you blew it. This way of thinking is not going to help you. You have to stop beating yourself up. Instead, think about what you could do better next time and move on. Moving on is your next best step.

Let me share a story with you. I have a friend who started her own salon. She did all the up-front work to make sure her clients knew she was moving and got all their contact information. When the time came, she informed everyone. Because of her prep work, she had a packed schedule at her new place in no time. She did it so well that another girl from her salon wanted to do the same. The problem is that when this other stylist felt the first twinge of growing pains and a little ounce of rejection, she was ready to throw in the towel. She assumed it would be easy, but she didn't take the time to find out how the first stylist was so successful. She didn't do the up-front work. She assumed her best friend would want to join her new venture, but that didn't happen either. She

was so disappointed and felt stuck. Here is my best advice for her. "Pull yourself together, sister. You are a great stylist. Love your best friend right where she's at and move on. Look at what the first stylist did to be successful, learn from her, and decide to do it the right way this time. You can do it, but you never will if you just sit around thinking about what went wrong and trying to convince those around you to get on board. Talk to another stylist, expand your horizons, cast a strong vision, execute that vision, and show people something exciting that they want to be a part of. You will have others join you, and your clients will follow if you do it with confident excitement."

This is what you need to remember: one person is not going to make or break your business. I know firsthand. My best friend—former best friend—poked holes in every idea I had. She told me I shouldn't start my photography business because my kids needed their mom home more. She made fun of me to my face and behind my back. It hurt. I thought she would be a great supporter of both my businesses. I thought we would be partners, doing these businesses together. The problem was that I wanted something for her that she didn't want for herself. Although it stung for sure, it wasn't about me. I lost a friend, but what I gained is more than I could have ever imagined. Again, I think that sounds cruel, as if people are expendable. That isn't how I feel at all. I loved our friendship, but there were a lot of things about it that were broken. I stayed in the friendship longer than I should have, and I mourned its loss for a few years. I also learned a lot of valuable lessons. When you have big ideas, you have to be careful that you don't align with people who don't want to see you succeed. Doesn't that sound crazy? Unfortunately, it's true. I experienced it, and I see it all the time. When you have big dreams, it can be scary for those around you. Maybe there's some jealousy? Perhaps they don't want you to go on without them? Maybe they're afraid you'll be too busy for them, or perhaps they are genuinely concerned about you taking this big leap of faith. Only you can evaluate these relationships and decide who's in your camp and who's trying to burn it down. It's never easy to cut ties, but some relationships are meant for only a season. Learn from them and grow from them, but

when it's time to move on, you have to decide what's more important, pleasing this person or achieving your goals? This is one of the toughest realities I have learned in business. I wish I didn't have to give it to you as a warning, but watch out for the pitfall of people-pleasing, especially when it's to the detriment of what you feel called to do.

I tell women who are considering being on my team everything that I've shared with you in this chapter. In any business, in any area of life, if you help others get what they want, you will get what you want. Breaking through obstacles, self-imposed or otherwise, works the same with anything. What works in direct sales works in any industry. Don't be afraid of objections. Look at them as an opportunity to start a dialogue; that's really all it is. Most likely you already know the answers to the most common objections you face; practice them and be confident when you talk about what you have to offer. If you believe in what you are doing, you will find others who believe in the same mission. Don't let a few negative comments take you off course. If you stay committed, you will be surprised by how many of those Aunt Sallies become some of your biggest supporters.

CHAPTER 10

What Makes You Think She's Better Than You?

But let each one test his own work, and then his reason to boast will be in himself alone and not in his neighbor.

—Galatians 6:4 (ESV)

Have you ever caught yourself comparing your journey to someone else's? They say comparison is the thief of joy. No matter how happy you are or how successful you are, and no matter how much you have, there is always going to be someone who looks happier and more successful than you. There will always be someone who has more than you. And from your perspective, it looks like it all came faster and easier for them.

Michael and I had been married for about ten years and our firstborn was just over a year old before we were finally making enough to have a little wiggle room financially. Against Michael's better judgment, I convinced him to join the local country club so that we could have a pool membership and a place to work out. I never exercised there, but

I did find myself poolside, ordering from the cantina any day I wasn't working and even some days when I was. I was living my best life, racking up a ridiculous summertime charge account, and feeling on top of the world.

One Sunday afternoon we met a super nice guy; he was playing in the pool with his daughter, who was the same age as our son. We quickly hit it off, but then we met the wife. I wish I could say it nicer, but that was my nice version. OK, she was nice—sorta. She was quick to let us know her husband was a surgeon. She also wanted me to know she didn't have to work. She was very proud of the new home they built in a very exclusive neighborhood, and she made sure we knew they only came to "this club" because their club didn't have many children.

From top of the world to bottom of the barrel, I left that day feeling like we were drowning. I was sure we couldn't afford to be there, and I was certain my cantina tab was going to tip the scale and land us back on our deck with our little guy playing in the sprinklers. Michael was so confused. He didn't suffer from the comparison game. He said, "You went from loving the country club life to feeling like we better cancel our membership and start counting our pennies." I couldn't explain it, but somewhere between feeling like our club was subpar and hearing about their steak dinner plans, I was certain we were in over our heads. As it turned out, we could afford to be there, but Michael was happy that I started packing snacks and not eating everything on the menu.

We remained friends with this couple for several years. We would enjoy evenings in their home and dinners out on occasion. They appeared happy enough, and she seemed happiest if they were doing better than anyone else at the table. Financially they were, but little did we know it was all crumbling at home. They both had a great game face, but things started to crack. I wasn't completely surprised when I heard they were divorcing, but I was shocked when I heard she was leaving him for her personal trainer. Personal trainer? Doesn't she know they don't make a ton of money?

"See, Michael, it's a good thing I don't work out because bad things happen when you do." Truth be told, I was guilty of comparing my life to hers. She was wearing all the designer labels I knew I couldn't afford.

She drove a car that I could only dream about. From the outside looking in, it seemed like her life was so easy and completely happy. Thank goodness I didn't let that have long-term influence over my happiness. I'm thankful I knew what true happiness was and I didn't place a dollar value on my marriage. How often do we compare and make crazy assumptions, and worse yet, base our decisions on what we see or think about others? It's dangerous for sure.

When you get caught in the cycle of comparison, you end up feeling bad about yourself for no reason. It's not healthy. It's not fair. After all, you aren't comparing apples to apples. Your experience is completely different from theirs. You rarely know the amount of work or the number of failures a person has experienced before they got to where they are. When you compare yourself to someone else, you're not seeing the whole story. You're seeing a very small part of their life and usually only the parts they choose to show. Don't try to compare your whole story to someone else's highlight reel.

What makes you think she's better than you, anyway? The pristine front lawn? She probably spends hours out in the heat for it to look that way. The nice, trendy clothes? She probably had to work two jobs to be able to afford them or worse yet be married to someone she didn't love. Her perfectly behaved kids? They probably have meltdowns when they're at home and keep her up half the night. Maybe what you are seeing is real, but behind those perfectly behaved kids, the well-manicured lawn, and a closetful of designer clothes, there has to be hard work in there somewhere.

You know who can teach us a lot about comparison? Justin Bieber. I know, you're surprised. What could we possibly have in common with him? Many say Justin was an overnight success. World-class talent manager Scooter Braun and R&B singer Usher Raymond signed him to a record deal at age thirteen. He went from publishing his own YouTube videos to packing auditoriums around the world with millions of screaming preteens and their bewildered parents.

Women don't regularly compare themselves to teenybopper superstars. Still, it's hard to hear about someone one-third or one-fourth our

age and *not* think, *That kid accomplished more before he could legally drive than I have in all my life.* It looks like Justin, Demi Lovato, Millie Bobby Brown, and so on (pick your kids' favorite teen celebrity) all "made it" from the start. What we *don't* know is what journey brought them there. How many noes did they get before that first big yes?

I did a little research on Justin. Throughout his entire childhood, Justin and his parents tried to get record executives' attention to no avail. Little Justin basically made it his full-time job to produce music—and he was just a kid! Justin didn't just jump on social media and gain an instant fan base. He had to post, post, and post again. Video after video, there was no guarantee that his hobby would ever amount to anything more. I'm sure he made sacrifices during his childhood and faced ridicule from others who thought his pipe dream was a complete waste of time.

Finally, after many videos, several posts, and a lot of effort saddled with plenty of rejection, Justin's social media presence started to grow. Not such an overnight success after all, is he? He had to work long and hard before he ever got recognized for his efforts.

When I started my direct sales journey, many people already knew me as a successful businessperson. But I still got plenty of noes. I kept working, and I worked hard. I worked this business at a pace that can't be overlooked. So when someone tries to compare their journey to mine, I remind them that anyone can do what I did if they're willing to work for it. Be fair in your comparison. I didn't become successful effortlessly. I laid the groundwork for success over six years with my previous business—just as Justin made professional-quality videos for years before anyone knew who he was.

I'm not trying to discourage you from going after your dreams. I'm telling you not to give up. Just because someone else already has what you want doesn't mean you can't still get it, too. Realistically, it may take you a few years to establish yourself in your venture. Whether you're starting a ladies' ministry, developing a side business, or looking for work again after years at home with the kiddos, the people whose attention you want may not take you seriously at first. That's OK. How

you handle getting rejected, or just as bad, being ignored, is what can make or break you. Confidence sells; desperation doesn't. If you're gracious to a no, the right people will be comfortable giving you a yes. I've gotten a lot of noes from people who later came back and said, "Wait, maybe I *do* want to be a part of this."

This brings us to *healthy* comparisons. Yes, these do exist. Another person's success can show you what is possible. This is particularly true with people who you'd like to emulate. They live an abundant life, they have a passionate marriage, they have respectful children, they have a booming business, whatever caught your attention. When someone else's life inspires you to transform your own, you're not sitting around wishing you were better than them. You're befriending them, learning from them, and aspiring to have a better life for you and your family. You're not trying to be exactly like them; you're letting them motivate you to find things that make you just as happy as they are.

Flip society's you're-not-good-enough script and view your role model's successes as mile markers for your own life. Instead of comparing what someone else has to what you want, measure your own progress relative to what *you* want. It's your life, not theirs.

How amazing would it be if we could put an end to the jealousy? To the cattiness and the gossip that so many women get pulled into? What if, instead of competing against one another, we inspire each other? What if we built each other up and helped each other do better, be better, get better, and live better? That's the kind of world I want for my daughters. It starts with us.

No matter how much you want to avoid negative comparisons, they'll still show up in the back of your mind. You're human. Give yourself some grace, remember? Try this. The next time you find yourself comparing your life to someone else's, and you feel that jealous, down-and-out feeling creeping in, interrupt it. Grab a piece of paper and ask yourself:

- What about this person do I respect?
- What impresses me?

- What could I compliment them on in conversation?
- What could I learn from them?

Write down your answers. Don't be brief. Then think about something in your own life that you want to change. With this in mind, ask yourself:
- Where am I right now?
- Where do I want to be?
- What am I willing to do to get there?
- What's the first step?

Your answers to these questions don't have to be huge. Maybe when you see your next-door neighbor post that she's already finished a workout by 7:00 a.m., it reminds you how much you're struggling to get to bed at a decent hour so you can get up earlier. Maybe you want to be asleep by 10:00 p.m. Maybe the way you get there is by putting your pj's on at nine o'clock and putting your phone away by nine thirty. Maybe this small change in your routine will allow you to have more energy in the morning and better focus throughout the day. I'd say that's pretty huge. It's all about training yourself differently. Set a reminder on your phone to turn off electronics, then abide by that new guideline. Set an alarm on your clock to get up earlier and then respect yourself enough to follow through with it. When we say we want something but we aren't willing to work toward it, we're really saying we don't think we deserve it. We're saying, "I'm not worth it, and my new goal isn't really what I want." Here's the other thing to remember. Your idea is worth it, and you are worth it. If you aren't happy with how things are going, only you can make the changes necessary to have a different outcome. That sounds easier than it really is, but I know from experience that most changes people want to make come down to the decision to take the necessary steps. Sitting in a place of unhealthy comparison isn't what's going to get you there, but looking to mentors, watching others who you want to emulate, and then taking action toward those goals is what will move the needle.

Maybe your aspirations are more complex. Maybe you don't like your job. You want to quit and start your own business. You have bills to pay, so you can't just quit tomorrow. The path to get there might be hard, but there *is* a path. What if you cut back on spending and start saving for an in-between jobs fund? I hear your question right now. "I don't know how to cut my spending." Grab some paper and write down your extra spending habits. Do you get a drink on the way to work? Do you eat out? Do you buy a shirt when you stop at Target for paper plates? Do you use paper plates? I just gave you several ways to cut spending, and if you're willing to compare your extras to mine, I bet you can find some similar ways. Healthy comparison right there.

What if you dedicate a block of time every Saturday to brainstorming a business plan for your dream job? Then when you're ready, you give your business a go part-time, short term. Eventually you'll be able to cut back your hours at the job you hate. Then once you've found a reliable alternative for earning an income, you'll be able to quit. If you put in the work, you *can* get there. I feel like I can hear your heavy sigh and additional laments. "My boss won't allow me to go part-time," or "I'm so busy I can't find time to focus on a new business plan or getting it off the ground." Time to grab pen and paper again so that you can answer these questions:

- What time do you get up?
- What time do you leave?
- Do you watch television?
- How are you spending your free time?
- Who do you spend time with?

Answer these questions, then decide if those people and that use of your time are bringing you closer to getting out of the job you hate and toward starting something new. I'm not saying drop your friends, but if they relish in your complaining instead of helping you brainstorm new ideas, let me suggest you limit your time with them.

One last story about comparison and spending time with the wrong people, then we are going to wrap this thing up.

I lost a good friend when I started my direct selling business. It didn't happen overnight but over time; it took me being successful before the wheels completely fell off. This was a friend who Michael would say was never a friend, but I considered her my best friend. We had a long history, but the history was always focused around her; she was always in the driver's seat. Her husband was financially more successful than my husband; her kids were a little older than my kids; when we vacationed together, they stayed closer to the beach while we stayed a row back because that was what we could afford. She was a supermom who cooked amazing meals, and I was not; no explanation needed there. Let's just say that she loved her life and I loved mine. Our relationship worked as long as she was in the driver's seat. As long as she felt like she was doing better than me. Then I started making some headway in our first (successful) business. She was unsure if this was a good use of my time. It took me away from my family and it limited the time I had to spend "hanging out with friends." She often told me how sorry she felt for my kids because I worked too much. Eventually she seemed OK with my new venture and was supportive in her own snarky way. OK, that was snarky. But she was snarky. Then came the double whammy. I started a new business and found myself having great success. This was more than she could handle. According to her, I had changed. I didn't see it that way, but our friendship had changed. She was no longer in the driver's seat. She was no longer the more successful of the two, and she didn't like this shift. She made fun of me to mutual friends, she was very negative toward me in person, and she even made fun of my faith to my face. The crazy part is, I still wanted to be her friend. It was such a bizarre turn of events. Eventually she stopped taking my phone calls, and surprisingly, the stress associated with that friendship melted away. It was for the best.

Here's the thing. Without realizing it, I was comparing my life to hers. I was making decisions in my life to keep her happy. I wanted the

friendship to thrive, and for it to do so, I had to make sure I stayed one notch below her. And I was willing to do it! Isn't that crazy? I see it all the time. We are so worried about pleasing others and making sure they feel secure that we will sacrifice what we really want or believe to be best because we don't want to rock the boat.

Here's the best part. Once that friendship dissolved, I was free to be myself. I was attracting hardworking, driven people. I was attracted to like-minded people who wanted to see me succeed as much as I wanted to see them succeed. Not that we thought alike or agreed on everything; we didn't. But it was OK to think independently. It was OK to want what I wanted; they were happy for me and I was happy for them. In healthy comparison, I didn't have to do everything like these people, but I could learn from them and apply their best practices to my goals and dreams.

Are you surrounding yourself with people who want to see you succeed? Are you supporting others and helping them get closer to their goals? It works both ways, and it's the best form of healthy comparison.

Comparing your failures to someone else's successes will pointlessly bring you down. Finding inspiration in what another person has achieved opens up an entirely new conversation. Comparison doesn't have to be the thief of joy. Healthy comparison can bring hope. Direction. Motivation. And yes, even joy itself. That's something we could all use a little more of.

CHAPTER 11

Risk, Regret, and Reward

For to everyone who has will more be given, and he will have an abundance. But from the one who has not, even what he has will be taken away.

—Matthew 25:29 (ESV)

Y ou're either a risk-taker or you're not. It's completely unfair, but I believe people get lumped into two categories: those who enjoy taking a risk and those who err on the side of caution. I would say I don't like taking risks while others would say I am a big risk-taker. I guess it all depends on what is at stake.

I don't like to drive in a parking garage because it feels super risky to me. First, I'm a terrible driver. The turns are sharp, and I have convinced myself there is a flaw in all parking garage engineering and I don't want to be in there when it collapses. Does that sound crazy to you? Go ahead and park in the garage, but I will park on the street and go feed the meter every two hours. That makes perfect sense to me. We all see risk differently, and each person has to decide what it's worth to them.

I don't ever want to jump out of an airplane, but I did go zip-lining, against my better judgment. I don't care if I ever ride on the back of a motorcycle. I absolutely will not go on any type of fair ride, and I would prefer if my children didn't either. The joy of experiencing the

ride doesn't outweigh the fear that something could go terribly wrong. Call me crazy but a tilt-a-whirl feels like a steel trap that, with one misplacement of a bolt, will cause you to go flying through the air. I'm not saying anything negative about the people who put the thing together, but I am questioning the accuracy of putting it together, tearing it down, moving to another town, and doing it all again. One of these times, they're going to lose a bolt, and I don't want it to be when I decide to get dizzy for the price of four tickets. No thank you.

This is how I look at everything. Is the desired outcome, the potential for enjoyment or the betterment to my situation, worth the risk?

I don't like the out-of-control feeling of being on the fair ride, so that risk is simply not worth it to me. I also don't like the feeling of being controlled by a time clock, so starting my own business didn't feel risky at all to me. Of course I recognized some risk, but it felt more uncertain to stay comfortable—or should I say complacent? Because staying comfortable also meant looking back with regret. I don't like the feeling of regret. Comfortable isn't always complacency; it could be contentment, and I'm all about being content. I find I'm most content when I'm in the middle of growing a business or working on a project. Have you taken the time to evaluate when you feel most content?

I was talking with a schoolteacher friend who has a brilliant idea to start an online business. We talked through the potential of the business, the upside if things go well, and the need for this type of business in the marketplace. The conversation was invigorating for me. I was in my happy place, encouraging this person to bring this business to life. It seems like the absolute perfect decision. The teacher agreed that he thinks it's a great idea and that it meets a large demand. He thinks it could be wildly successful, and he would enjoy building the business and watching it grow. When we hung up the phone, I was certain he was going to pull the trigger. I called him a week later to hear how things were going and to see what kind of progress he had made. He still believes it's a great idea, as do others, but he's afraid to let go of the guaranteed salary of his teaching job. Every reason he gave is legitimate, with two kids in college being the more prominent. He hasn't yet decided that the risk is worth it to him.

I have to wonder how many great ideas never come to be because of the safety zone, the legitimate reasons that get in the way. I have to wonder how many great ideas never come to be because people are afraid to take a chance on themselves.

Relying on corporate America always felt risky and out of control to me. I didn't like being at the mercy of someone else deciding where I needed to be, at what time, and for how much pay. I wanted to decide all those things, and I wanted to do something that rewarded my efforts. I wanted to have an earning potential based on my effort, not based on a standard salary cap.

This may not be the case for you, and that's OK. My son is not going to be one to take risks when it comes to his career. We call him safety boy for a reason. He likes to know the plan; he likes the traditional way of doing things. He likes to follow the path that's been laid before him. I love people like this. I don't always understand them, but I appreciate them nonetheless. We need people who think this way. We need people who work in the traditional sense. It would be a crazy world if everyone was in a start-up mentality. So if you find that you prefer the comfort of the knowns, that is not wrong. Knowing that about yourself will help you tremendously.

Here's an example of not knowing this about yourself and why it can cause problems. I am a dreamer, a big vision caster, and that can be overwhelming—or to put a little more bluntly, overbearing for some people in my life (i.e., my children). I talk about start-up business ideas all the time and often say to them, "You should do this, Kyle, and if you wanted to do it with your sister, that would be great." I will have the equipment planned, the business named, and the big-picture ideas formulated before they even have a chance to say they don't want to own a cupcake food truck, a delivery concierge service, a boba tea business, or any of the other great ideas I've conjured up over the years. I think because they've heard this banter for so long, they've convinced themselves that being an entrepreneur is right for them. But let me tell you how it always plays out and why they will soon learn this probably isn't the gig for them!

Earlier this summer our fourteen-year-old decided to start a small-batch custom soap business. His first mistake was telling me. I went into full game-on mode. "Let's do it. This is going to be amazing. You should call it this, we can do different molds, different scents, different colors. This is going to be awesome!" He was excited. He figured out the supplies, ordered them, and started the first batch, which yielded a big mess, ingredient errors, and a lot of wasted time and resources. This would not have been a deal breaker for me. This is the way you learn. My mentality is to figure out what went wrong and start again. He decided to go to bed. What? OK. It was late, I will give him that, but never in my wildest dreams would I have gone to bed before making a second attempt, or even a third or fourth if it was necessary. This is how I am wired; this is not how he is wired. I have to respect that, even if I don't understand it. The next day he made his second attempt. He made some adjustments, and his cupcake-shaped soaps turned out great. OK, that's the mom in me talking. They were just OK. They weren't great, but they were soap. They were shaped like cupcakes, but they looked odd; the coloring wasn't good. Truth be told, other than lathering up and getting your hands clean, they had zero redeeming qualities. And I know what you're thinking—no, I didn't say this to him, but he can read it here!

What happened next is the proof that he is not cut out to be an entrepreneur. Before I continue, you might think it's harsh that I'm counting him out because of one failed business idea. It's not because of one failed idea; it's because of his response to ideas over and over and how he responded to this idea. He never made soap again. He still has plenty of supplies but no desire to make any more soap. Now, it's easy to think, *Of course he doesn't want to make any more soap; he's a fickle teenager*. This is the part I can't relate to. I would expect him to keep making soap, even if just as a hobby, until he got it so good people were asking to purchase it. That's just how my mind works but not his.

This was a great lesson for all of us. Now when I have great business ideas, I don't put them on my child with a level of excitement and expectation that is met with complete indifference. And he has recognized that he likes structure. He likes being an employee and helping make a

company great. He is an A+ employee and excellent team member. He likes someone else to cast the vision; he wants to be a part of it but not the one solely responsible for it. What a great thing to understand about yourself at such an early age. And who knows, maybe the entrepreneurial spirit will hit him later in life after he's worked for other people.

That may not be the best example of how to determine whether you are cut out to be an entrepreneur because all risk is not created equal. What feels risky to one person may not feel risky to another, and only you can decide what it's worth to you.

Let me share two very different stories with two very different levels of risk. One was fun and one was life changing.

In 2008, I was a contestant on the *Price Is Right*. If you've never been on a game show before, it's kinda fascinating how the process works, and I was completely amazed by how quickly I lost my senses and got wrapped up in the game.

Follow me here. My name is called: "Jessica Bettencourt, come on down! You're the next contestant on the *Price Is Right*!" I love the *Price Is Right*. I watched it all the time growing up, and I knew every game. I wanted to play Plinko as much as I wanted anything in life. My best friend, Trina, and I arrived at the studio with self-made, iron-on T-shirts that read i want to play plinko and i want to spin the big wheel. We had no idea what the process was to get on the show, but we were there for the long haul. They give you a number, line you up, and as you walk into the studio, they do a thirty-second interview as you pass a few producers. There were 320 audience members that day, and we were numbers 309 and 310. I was certain they had already found the twelve contestants, but I was happy just to be in the audience. It felt like a dream come true. Little did I know that in just a few short minutes, my real dream of being on that stage, kissing Bob Barker, and making an absolute fool of myself was about to come true.

My best friend convinced me to wear tennis shoes that day with my capri pants. I have one hard-and-fast rule in my life, which is that my shoes are *always* cute and appropriate for my outfit, comfort aside. This day she said, "We are going to be doing a lot of walking, and I don't

want to hear you complain about your feet hurting. Would you please wear comfort over cute?" I agreed. The one day I break my hard-and-fast rule is when I end up on national television, but that has very little to do with the story. I just want you to know that if you ever see the show, I know my shoes don't look good with my outfit.

So I end up on stage, and I'm playing a game called Put It in the Bag. I have a chance at $16,000! That's a lot of money, and I don't like to take risks when it comes to money. But here I am, on stage with Bob Barker. I have to put certain grocery items with price markers. I get Smucker's jelly right, and I have $1,000. Then I get the electric hair trimmer for $9.99, and my money doubles to $2,000. I should have stopped there and taken the money. But the crowd is yelling, it's all going so fast, and Bob Barker is so convincing that I decide to take a chance on the Pringles for nine-ty-nine cents, and boom, I land $4,000. Stop, take the money, and laugh all the way home—this is amazing! Again, the crowd is cheering, and I'm scanning the audience, trying to find my friend Trina. It's all happening so fast that without even thinking, I say, "I'm going to go for it, Bob!" I put $4,000 on the line, and I'm sure I have the next item correct. I'm giddy with excitement, convinced I'm getting ready to win the big bucks. The crowd is roaring, and it feels like my life is moving in slow motion. I can see the money, and then out of nowhere, I hear *womp, womp, womp*. I had the last two items confused, and I lost it all. I lost $4,000. What just hap-pened? I don't gamble, and I don't take risks with money. It was terrible, and I felt sick. I was so disappointed that I took that chance. But I had to keep it together because now I needed to spin the big wheel and make up for my mistake in the Showcase Showdown. I told myself to focus and spin a 100. I spun a 65, and because I absolutely couldn't think straight, I held there and was promptly knocked out by the next contestant. I was sick over losing that money, absolutely sick. I called Michael and told him everything that happened, and when I asked if he was mad about the money, he said, "No, I'm mad that you held at sixty-five." It turns out that 65 is the worst spin for the first contestant. I wish I didn't know this to be true, but Michael and some of his nerdy friends ran the analytics on it, and I couldn't have had a worst first spin, but I should have at least spun again.

I can laugh about it now—it was a super fun experience—but here's the crazy part. I beat myself up over that game for a long, long time. Something so random, a chance happening, and yet I let my risk guard down, and look at what happened. It's not that big of a deal, but it's interesting that under normal circumstances, I would have never risked that money on a chance.

Now, here is a story with a completely different level of risk with a reward beyond my wildest dreams.

Let me share with you my seventeen-year prayer journey to adopt a little girl from China. It all started in our fifth year of marriage, before we had children of our own. We had built our first house, and shortly after moving in, I heard my husband talking in the driveway. Eager to meet the neighbors, I went outside to find him speaking with the cutest little Chinese girl I had ever seen. I hear her say, "I'm four and I wear size four panties." He wasn't raised with sisters, so he wasn't exactly sure how to respond. The next thing that happened might be what caused me to fall in love with her. While Michael was eye level cleaning his wheels, she picked up the water hose and said, "I will spray you." Again, not sure how to respond, he said, "Oh no. Don't spray me." She promptly sprayed him right in the face. It was absolutely precious!

Her name was Katelyn, and we loved watching this little one grow. We became great friends with her family, and I knew she was placed in our lives for a reason. I told Michael that we were going to adopt a little girl from China, but he was not so sure. He would say, "I'll adopt Katelyn, but I'm not interested in adopting for real." Over the years I felt God put adoption on my heart, but it was always met with resistance from Michael. His parents had hosted some foster daughters, and it wasn't always a great experience. He had conjured up all kinds of reasons why adoption wasn't a good fit for us. Money was by far the easiest excuse to justify. It's very expensive to adopt. Data shows that over 70 percent of people who say they would be willing to adopt turn back because of finances. So if you ever know someone who is willing to adopt, if you can support them financially, please do. Every little bit helps, and you could be making a huge difference in the life of a child.

This is the route we decided to take. Michael would not agree to bringing a child into our home, but he did agree that we could set up a foundation to help other families adopt. This gave me peace for a while, but I still felt that tug on my heart that we were supposed to adopt a little one of our own. I would pray about it, ask God to soften Michael's cold black heart, and then I would help other families bring their little ones home. This brought me great joy.

Then one day I was at a gathering with several adoptive mommas. One of the ladies asked my name, and when I told her, she said, "Jessica, this is our daughter from China. You helped us financially." Another woman piped up, and said, "Jessica, it's nice to meet you. You helped us, too." She pointed to her daughter, a sweet little girl from China. And if that isn't crazy enough, another lady said, "Jessica, you helped us with our travel to China. This is our daughter." What are the chances that three families would recognize my name and introduce me to their daughters from China? I knew God was using this day to confirm what I had felt for years.

As I left that day, I began to pray, then I began to have a very firm discussion with the Lord. As if he needed me to tell him how things were going to go down. "All right, Lord, I am not bringing this up. If you intend for us to adopt, you are going to have to soften that man's heart. I am not saying a word; he needs to bring this up. Lord, if you want us to adopt, you are going to have to place it on his heart and he is going to have to say something because I am tired of talking about it. I'm not saying a word. Lord, I have tried to convince him, but it's going to take you."

I walked into the house, and when Michael asked how the party went, and I looked him square in the face and said, "We're supposed to adopt a little girl from China." Yes, I know what I said about not saying a word, but the Lord is sovereign; he knew I wasn't going to keep my mouth shut.

Then it happened, and I wanted to kill him. Michael said, "You haven't mentioned anything in a while, and I've just been waiting on you to bring it up. I agree, we are supposed to adopt."

"What in the world? Are you crazy? We're old. You should have said yes years ago. Our kids are big, we are beyond the baby phase, we

can't travel to China for two weeks. Have you lost your mind? Why are you saying yes now?"

You see, I had gotten comfortable with Michael saying no. I looked like the martyr; I wanted to do the right thing, but he didn't. I wanted to take care of the orphans and the widows, but because Michael wouldn't agree, I could only do so much. It was easy to send a check, and it was easy to pray for others. Now I had to do the hard part. I had to put my money where my mouth was.

We started the process, and through a series of events, we found our precious Carson Jane. I'm not going to lie; I was scared to death. What in the world have I done to my perfect, easy family? What if this child hates us? What have I done to my other children? I had all kinds of concerns, some so unfathomable and selfish that I don't want to admit to them. I prayed daily. I prayed all day some days. I prayed big, bold prayers. I knew we were called to adopt, but I wasn't sure I was ready for it. I wasn't sure I was cut out for it. It felt very risky. It could completely upset the very life I had worked so hard to build.

One evening at family dinner, we were discussing all the changes to come. My middle son, Kyle, could sense the hesitation in my voice, as I seemed to be apologizing for what I had gotten us into. I know that sounds harsh. I felt like I had convinced my family to adopt, and I had conjured up all the things that could go wrong. In his twelve-year-old wisdom, he said, "Mom, it's not going to be easy, but we weren't called to easy. God didn't say go live a comfortable life. He said love others, take care of others. This little girl needs a family. It's not going to be easy, but it's the right thing to do."

And with that, we were on our way. I didn't read all the books. I didn't join a support group. Maybe I should have, but in typical Jessica fashion, I knew I could figure it out, and that's what we did. We flew to China as a family of five and came home as a family of six. I could share story after story of how God showed up and answered those big, bold prayers. I could share how some of my greatest concerns were silly and never an issue. I could also share stories of how many of my biggest fears weren't big enough. It was hard on a different level. It was more emotional than

I could have even imagined. It has also been more beautiful than I could have ever hoped for. We have been blessed by this little girl in ways we couldn't have seen coming. And those big kids of mine, they have grown in ways every child should be forced to grow. If you want to teach your children about compassion, adopt a medically fragile child and watch your children show empathy on a level you didn't know existed.

Was it risky? It was. Was it worth it? Absolutely. We often joke that we used to live on Easy Street but we moved to Crazy Town—and Carson is the mayor. Nonetheless, I'm still not going to drive into a parking garage, and if Carson wants to ride a roller coaster, she'll need to get her big brother or her dad to go along. But I am her person, and opening my heart to this little one has been the best risk I could ever have imagined.

CHAPTER 12

How to Change Course When You Feel Like Quitting

Do you not know that in a race all the runners run, but only one receives the prize? So run that you may obtain it.

—1 Corinthians 9:24 (ESV)

I f you choose a traditional path after high school, you probably go to a four-year college, graduate with your degree, and soon after you land your first job. But what if you hate it? What if you don't like the people or you don't believe in what you're selling? Do you regret getting your degree? Do you decide three months in that your chosen profession isn't a good fit for you, quit your job, and go back to school to start over?

Probably not. But that doesn't mean you have to stay at a job you hate. You don't abandon your journey altogether—you simply change course. The same is true no matter what season of life you find yourself in. Don't throw in the towel. Wash it!

When you're in the thick of it, the progress you're making on your journey can often go unnoticed. You can get tunnel vision on the one

thing that didn't go as planned instead of appreciating the improvement from all your hard work. When I worked for the plastic surgeon, we would often do surgery on someone that gave them a dramatic change. But instead of appreciating that change, they became hyperfocused. All of a sudden, all they could think about was that they still had a funny little lump, even though it was three sizes smaller than before surgery; they would notice an area that didn't seem perfect to them. They couldn't appreciate the progress as long as there was still one spot that didn't look the way they wanted.

Is success settling for a less than perfect outcome? Not necessarily. But success does require a little patience and a lot of consistency. I always tell people if they want to have success, do the same thing over and over. Soon you can look back and realize how far you've come. When I first joined a fitness group, I saw how strong all the other ladies were. I couldn't lift my body or stretch that way. I felt like I'd never be able to. Six months later, my instructor stopped me one day to tell me I had great form. I could see that I was making real progress, and I was doing the same thing over and over. That's how you improve at anything. Don't be afraid to make mistakes as you find what feels right.

And Lord knows I'm not afraid of making mistakes! When my kids do something I don't like, I react. But I ask myself whether that reaction gets me the results I want. If not, then I have to change something. I don't write myself off as a horrible parent. I wash that towel and correct my course. Maybe I try a tactic and it doesn't work. Then I try something else, and it doesn't work. Then I try something and it's like a light bulb. My child responds well, and I feel lighter. So I keep doing what works. Pay attention to what you're doing and to the responses you get. Then you can make changes as needed to get you closer to where you want to go.

If we don't pay attention, you know what happens? We ignore what works. We all do it unintentionally at one time or another. I recently stopped eating wheat and sugar, and I'm amazed at how different I feel, especially in the afternoons. Last week, for some reason I let myself

have a chocolate doughnut for lunch. On the drive home, I had a gross, sluggish feeling. Even though I knew what worked for me, I didn't pay attention. But you know what? I'm paying attention now. And I won't make that mistake again anytime soon.

I don't feel guilty when I make a mistake or a bad decision. Women feel needless guilt too often as it is. Moms especially feel that guilt. Every time something happens that we didn't intend, we feel guilty that we didn't make different choices. Better choices. Because we want to nurture and love our kids, but boy is it a lot harder than most of us expected. You find you're not as patient with these adorable little beings as you want to be. Now that you have them, they're talking back to you, screaming, and throwing their food across the room.

One day Michael came home and said he was going to mow the lawn.

"Oh, that's OK. I'll do it. You play with the kids." I'd taken care of our three littles all day and I needed *out*.

"Uh, Jessica, you've never mowed a lawn before in your life." Michael raised an eyebrow at me.

I shrugged. "Can't be that hard." Anything for a break.

I took his iPod out of his hand and charged into the garage. Starting the mower was surprisingly easy. A few yards into the mow, I was on a roll. I looked up and waved at our neighbor. The next thing I knew, I'd hit a tree root. Michael's brand-new earbuds yanked out of my ears, sending his brand-new iPod underneath the mower, through the slicer, and out the other side. My reflex to kill the power on the mower was a second too late.

"Mike's going to kill you," my neighbor called to me. "If not for the iPod, then for the terrible stripes on your lawn."

I didn't care about the stripes. Or the iPod. I would have done anything to get out of that house.

Looking back, rather than allowing each day of mothering three small children to completely exhaust me, I wish I would have done some self-reflection by thinking about what was going well and giving myself some attagirls for those things as well as what was causing so much tension and looking for ways to improve those areas. Raising kids

is exhausting, but chances are, with a little grace and a willingness to self-reflect, there are things that you can work on to improve the circumstances. Maybe it's as simple as not letting your kids get completely hyped up on sugar, even though they really want those sugary treats. Perhaps it's being more dedicated to a routine and nap schedule, even though you like to be the spontaneous mom. It's hard in the moment, but stop and recognize some areas that need to be reined in or perhaps loosened up a bit. Show yourself some grace. I'm sure you are doing better than you think.

Too often people don't look at the uncomfortable and try to figure out why they feel that way. They don't look at the negative result and piece together why it happened. Instead, they look at the less than stellar situation and blame themselves. I can't tell you how many times the new salespeople in my company tell me, "I talked to a few people. None of them wanted my product, so I can't sell it." Maybe so, but probably not. Think about how you presented it. Think about what you talked about. What went well in your sales pitch? Keep doing more of that. Correct your course instead of abandoning the journey.

Take a moment now to evaluate what you're working toward. Is it what you want? If you've made it this far in the book, then you've probably already said your goodbyes to the things you *don't* want. If the destination you're seeking is what you want, that's your reason to keep going. Even if the journey is long and hard. If you want to get there, you *can* find a way. Maybe you've been taking the long way around, and it's time to look for a more direct path.

When you realize that your journey is harder than you expected, it's normal to want to cancel. Heck, I almost cancelled a million times. The little voice in your head telling you to give up will always be there. But that doesn't mean you should listen.

Because you know what? Everything takes longer and costs more than you expect. That's true for starting a business, raising children, and building a house. And if you understand that going in, it will be a lot easier to navigate and correct the course when needed. You're also not going to be devastated every time something doesn't go as planned.

Pain is an inevitable part of life, but when you expect it, it hurts a lot less.

The more you practice and the more you improve, the closer you get to that magical success. Practice your sales pitch. Practice patience with your children. Practice cooking. That's some advice I need to take—I'm a terrible cook! If you eat at our house when I'm cooking, you won't go away hungry, but you won't leave impressed. If you eat Michael's cooking, you'll enjoy every bite. Now, I'm sure if I put in the time and effort, I could figure out why my last casserole didn't turn out right. I probably didn't follow the instructions. I know that if I want to improve (and I know my family wants me to improve), I need to treat cooking like everything else in my life. Instead of ordering pizza, I can take notice of what works, let go of what doesn't, and do the same thing over and over until everyone is licking their plates.

CHAPTER 13

You Don't Need Rags to Have Riches

One who is faithful in a very little is also faithful in much, and one who is dishonest in a very little is also dishonest in much.

—*Luke 16:10 (ESV)*

I was never motivated by money in the sense of getting rich. I was motivated by money in the sense of stability. I didn't want to have to budget for food. I didn't want to carry a calculator at the market. I wanted to be able to afford groceries and to eat out occasionally.

When starting our businesses, I was motivated by my time. I hated being responsible for clocking in and clocking out. I didn't like selling my time for such little money, especially when I felt like I could produce more and achieve more on my own terms. Time freedom motivated me first and foremost. Then financial freedom. A close second.

Michael helped calm my money stresses because I knew he was going to manage our finances and make sure we were making solid decisions. Needless to say, he took care of paying the bills. Remember the late fee story? Yeah, he wasn't going to let that happen again.

I never focused on how much money we made, but I wanted to know that our finances were in order. If all the bills were paid and I didn't need

to be super frugal at the market, I was happy. That was my definition of success: solid grocery money.

Early in our marriage, I would ask Michael if we were doing OK. If he said we could be saving more, I would immediately go from normal groceries to hot dogs and ramen. Michael didn't understand this mentality. He never found himself broke and struggling to pay the bills, so this didn't resonate with him. He would remind me that we were fine and that everyone could stand to save more money. It took me a long time to regulate my fear. I still check in from time to time with him. "Michael, are we doing OK financially? Are things good? Do we need to reel it in?" He says I don't understand money; I say I understand not having enough.

I tend to be full on the throttle. At eighteen years old, I was willing to do whatever it took to make my own way in the world. My determination and willingness to go all in has served me throughout my life. My tenacity and my ability to just make things work has also contributed by and large to my success.

People are blown away when they hear all the details of our story, but it can leave them questioning whether they could have done it. Here's the deal. You don't have to come from hardship to have a great story. I know people whose parents took care of them well into their twenties, set them up in their first home, and rescued them every time they had a problem. At some point, they either figured it out or they didn't. I know people who went to very prestigious schools who never landed that dream job; they either found a different path or they didn't. This is just my path. Maybe your journey looks similar, or maybe it was harder or easier. At the end of the day, what matters is that you figured out who you want to be and you worked to get there. Or you are now.

Plenty of people have great success without coming from beginnings similar to mine. But you have to be committed to making it. When I started my second business, I certainly wasn't hungry. I wasn't struggling in any way, but I was determined—there was still more I could do.

I'm facing that reality again as a speaker and an author. I have to take my own advice. I can get caught up in comparison or feeling like maybe my story isn't important. I've never had cancer or an addiction,

so I don't have a great story to share about survival. I don't have a ready comeback story like many speakers talk about. Just last week, I watched someone speak who had been a kidnapping victim. Her story was captivating. My story is nothing like that. But I do have a story. If I want to be successful in this industry, I have to be brave enough to share it.

What do you have that will help you be driven to success? It might not be a tough past. It might not be a desire to make a drastic change to your life. Maybe you want to be able to give to an endeavor that you currently can't afford to contribute to. Maybe, like me, you are ready to stop trading time for money.

I recently had a conversation with a friend in another direct sales business. She said to me, "I just want to have enough extra money to be able to live. I'm tired of always saying, 'No, I can't buy those pants,' or 'No, we can't stop for ice cream.'"

At the end of our conversation, she realized she wasn't willing to work as much as she needed to. She wanted to spend more time with her daughter before she went back to college. So I helped her figure out how she could have that time with her daughter and work her business. I helped her see how she could reach her goals by prioritizing what mattered. Afterward, she sent me a message.

"Thanks for today, Jessica. I really appreciate the encouragement. You didn't make me feel like a failure for wanting to spend more time with my family. Thank you for helping me see areas where I could use my time better and have time for business and my family. I need this business to work and I feel excited to work on the things we discussed."

You have to decide what success is worth to you. You may not be willing to go through all the pain points that I went through, but only you can determine what you are willing to do and what it's worth to you.

If you could project yourself three years into the future, what are your absolutes? What are the things you know you cannot change? What do you know you need to have? For me, in three years I'll be forty-nine. I'll most likely be living in the same house. Most likely I will be driving the same car. I'll have an eighth grader, a third grader, and a senior. Oh, and one graduating college.

What things in your life right now do you hope will be gone in three years? If three years feels too long, switch it to one year. I normally do three years with the ladies in my business because I've seen what a solid three-year commitment in business can do compared to a thirty-year career in corporate America.

Fast-forward to where you want to be and work backward from there. Rather than focusing only on what you do and don't want in your life three years from now, choose your objective first. If you know you don't want that extra fifty pounds, or you don't want to be driving to the same job, or you want to stop using drinking as a coping mechanism, then what does it look like when that's not a part of your life any longer? Clarify the absolute objectives of what you want your life to look like.

Once you decide what your big goals are, figure out what you need to change to get there. Once again, grab a notebook and write out what those key desired results are—the measurable things that you could do to drop ten pounds, or quit smoking, or whatever it is. Then make a plan with daily, weekly, or monthly actions to bring you to that goal. When you get to that year-three mark, more will have changed than only the date.

If you aren't confident in your decision-making skills, start with small decisions and build your way up. I encourage people to make decisions when they feel afraid to do so, then evaluate them. If you see a pattern in your life that is focused around a bad decision, take the time to evaluate what needs to change regarding this circumstance. For example, if you've started four different unsuccessful side businesses over the years, it's likely the same doomed business model over and over and over. After the first flop, evaluate what you don't want to see again. If you want a different outcome, you have to be willing to change something. As the saying goes, it's not me . . . it's you.

When I started both of my businesses, I went step-by-step. I told myself, *All right, now that I've done that, I can do this*. That's how I moved forward, one step at a time. I didn't set out to be a top achiever or dream of being a Mercedes driver. Those were never my goals. My goal was to determine what I needed to try next. First it was to make that $500 a month. Then once I made $500, how could I double my efforts

to make $1,000? Once I made $1,000, how could I make $2,000? And the month I made only $1,500, that was still progress. I learned to evaluate what went well and what needed improvement, then I took those necessary steps.

When people understand how little I knew about entrepreneurship, or how little I knew about photography, they realize that if I could figure it out, anybody could. But my goals are not your goals. If you determine what your goal is and what you're willing to do to achieve it, chances are you can get there. It's often as simple as a shift in mindset—understanding what it will take instead of telling yourself you could never do it.

TO EVERYTHING A SEASON

Have you ever told someone you have organized chaos? I certainly have. But I don't feel like my life is chaotic. I'm content in my chaos because it is leading me to where I want to be. If somebody else stepped into my life for a day, they probably wouldn't see it that way. But I love my life. I schedule my days, and I enjoy my level of busy. As I write this book, I'm also growing my speaking career, and I'm teaching my fourth little one how to read. I move forward from a place of joy and contentment. And I have so much to look forward to each day.

I know it can be hard to find things to look forward to, especially when you're in a tough season of life. As you stare into the eyes of your crying infant at 2:00 a.m., it's easy to wish away the hours. Instead, try to think of practical things you can look forward to in your day. What can fit into this season of being a mom? What things can you look forward to that are constructive and helpful? Not, *I look forward to going out and getting trashed this weekend*, or *I look forward to that doughnut I have every morning*. Think, *I look forward to my daughter's next giggle attack*, or *I look forward to going on a walk with my family*. These things don't come easily at two in the morning, so write them down as you think of them. Jotting them into the notes section on your phone is

easy; it's better than scrolling Instagram to numb your mind. Keep that list handy and take a peek at it whenever things feel dismal.

Also understand that everything is a season. What about this particular season could you relish? Because this season will change, and if you're too far forward in your thinking, you miss those temporary things that need to be enjoyed. It's frustrating when people tell you that you should just enjoy this time in your life. That's hard advice to follow when you're in the thick of it and you're not getting a break. I find that when I get even a small reprieve from a challenging circumstance for a few hours, I can come back refreshed and able to find things to enjoy. Give yourself space to see the value in the hard times, and search for ways to make it easier or more fun. Have an honest conversation with your significant other and be clear about what you need. Don't feel guilty about asking for girlfriend time, an evening out, a child-free bath, or whatever speaks to your heart and is feasible at this time in your life.

Here's a tip I give to budding entrepreneurs or young moms wanting to get back into the workforce. If you're about to make big changes in your life, take the time to set yourself *and* your family up for success. If your husband is used to coming home to an organized house, kids content, and dinner on the table, and then all of a sudden he's walking in the door and the house is in complete disarray, the kids are screaming, there's no dinner, and you say, "Here you go. I'm out," you have set everyone up for failure. Set your significant other up for success. Because when they succeed, you succeed. When I started hosting evening events in my skincare business, I scheduled my day differently to make sure that when Michael walked in the door, it wasn't pandemonium. We also talked about things ahead of time so that he wasn't feeling like he didn't sign up for this. Bitter resentment builds up fast if you do not communicate. Maybe your husband gets to drive away each day. He's gone for eight hours, he has a great lunch with his buddies, and then he comes strolling in that evening as the hero. You're the frazzled stay-at-home mom, and somehow you're supposed to have the kids happy and dinner ready, too? Effective communication can help both of you help each other. Don't wait until you feel defensive or accusatory. Talk about the

changes and sacrifices that will be needed to allow you to pursue your new venture or passion. Help your family see that when you get to fill up, you can pour out more for them.

Communication skills haven't always been my strong suit. I learned from my mistakes—lots of them. I'm still not great at telling people what I need. There was a period in my life when I thought I shouldn't *have* to tell people what I need. I'm going to say this in case you need to hear it. People don't know what you need. Making that assumption sets everyone up to fail. They can't read your mind. Have those critical and honest conversations with your partner to make sure that the workload is balanced and that each of you is getting what you need. Be honest, not bitter or angry.

These days Michael and I have a fifty-fifty split in how we manage the household. We both work (hard), so it's different for us than for a family with one breadwinner. Is this a good thing? I don't know, but it works for us. Understand the value in each season, even the tough ones. What can you add to this season of life to boost your enjoyment while nourishing your connection with your family?

You can always find things to add to a negative experience to improve it, but you can't run away from it or speed it up. There's a book I read to Camden when he was five, and I just had Quincy read it. It's called *Let Me Hold You Longer*. It's told from a mom's point of view and talks about all her child's "lasts." We often think about the first time our kids walked, the first time they spoke, or the first time they slept through the night. But those lasts are bittersweet. The last time that they sit in your lap, or that you read to them, or that you rock them before they squirm away. My oldest is six foot six. I walked up behind him the other day and rubbed his shoulders, and I was overwhelmed by how he's grown up. It makes me cry to think that soon he's going to be on his own. We overlook so much while we wish away the present. Don't rush it. Because when it's gone . . .

You can look for ways to enrich your life without squelching the beauty of the season that you're in. Maybe you're taking care of an elderly parent. It is so hard to be in that place, every single day, never

ending. But at the same time, when they're gone, you look back and realize the time was still too short. There are always things in life that you're going to wish you had done differently. Be OK with that. Don't spend your days wishing. That's just life. Instead, correct your course for the now and for the future.

Because when you do, you arrive at a beautiful place where you can say, "I did the best I could in that season of my life. I did the best I could under the circumstances." If you are harboring guilt, let it go. If you know you did your best, then that's really all anyone could ask from you.

I've been thinking about my son leaving home, and all of a sudden, I had this bubbling over of things I should instill in him. I wonder if we have equipped him properly for the world, and I start to feel that guilt creep back in.

"He needs to know how to change a flat tire," I said to Michael the other day. "And he doesn't know how to start a grill. What else have we forgotten to teach him?"

"I think he'll be OK," Michael said. "We've taught him how to think for himself, and we've taught him the importance of his relationship with Christ. He knows we're here for him, and he's smarter than you give him credit for." He is a super smart boy, but there are days I think he and his father could be a tad stronger in the commonsense arena, but I'm sure they wish I had a better grasp on math.

It's true, we have done our best. Children don't come with a manual, so you have to figure it out. No matter what situation you're sending your kids into, it's natural to be worried for them. As they head off to kindergarten, you worry about whether you've given them everything they need. Have you taught them how to make friends? Have you given them the right tools to stand up for themselves while being kind to others? I think of it like the 80/20 rule. About 80 percent of the time we get it right. The other 20 percent of the time we don't. Parenting is hard. But our kids are resilient, and you can trust that they'll figure it out.

And you can trust in yourself, too. Your seasons of life will come and go. Some will be tougher than others. You'll make choices you wish you hadn't. You'll slip and do or say something that's not aligned with who

you want to be. But now that you've started your journey to where you want to go, you'll know how to correct your course. You'll make healthy comparisons that encourage you along. You'll make small adjustments instead of starting from scratch. You'll give yourself grace and offer it freely and lovingly to others. You'll embrace the lessons that God offers you. You'll learn from any mistakes and move forward with joy.

Most importantly, you won't cancel. You'll show up.

Here's the deal, friend. I'm rooting for you. You deserve to be successful, whatever that looks like to you. I hope you feel encouraged. I hope you are going to adopt a no-cancellation policy and promise yourself you will show up. Then follow through. Show up in the fun places, the hard places, the places that excite you, and the ones that stretch you. I promise you won't regret it. It's in those places where you will grow and learn and expand.

All right, get to it!

Just one last thing. Don't be a stranger. We didn't come this far to lose touch. I want to hear from you and celebrate your successes. You can find me through social media or sittin' on my porch, cheering you on.

ACKNOWLEDGEMENTS

I have so many who have helped me along the way. My Jr. Bridesmaids—Cindy, Holly, Stephanie, and JoDee, thank you for speaking life over me when all I wanted to do was cancel. Jonathan, thank you for understanding when Michael and JoDee were trying to work me to death. I know you get it, my brother. Thank you Phebe, Joshua, and Emily for never quitting on me. Thank you Trina and Jeff for helping me make sure my Southern slang wasn't too southern. Who knew grammar was so important when you are writing a book? Debbi, Wendi, Crystal, Romi, and Sarah, your leadership in my life is not to be forgotten, I can't thank you enough. Kim, your friendship and support mean the world to me. Heather, your encouragement carried me on days I didn't feel qualified to write a book. Jamie and Aubrey, you've both taught me so much and helped shape who I am today. To all "my girls" and my About Face team who took a chance on yourselves and allowed me to be your biggest cheerleader, "thank you" will never seem enough.

ABOUT THE AUTHOR

Jessica Bettencourt is an entrepreneur, speaker, and business coach who inspires women to believe in themselves, recognize their God-given talents, and take the next right step. Where others see obstacles, Jessica sees opportunity.

Jessica has built two distinct multimillion-dollar businesses from the ground up. Before starting her first business in photography, she had never held a professional camera. Through the help of other partners, that business is now a nationwide brand with over $40 million in annual sales. In her second business, Jessica quickly rose to the top ten consultants in a premium skincare network marketing company, amassing a team of more than eighteen thousand and annual sales of over $30 million. Prior to her entrepreneurial journey, Jessica held positions in pharmaceutical sales, communications, and health care.

Jessica is momma to four amazing kiddos; the youngest is an adorable little one from China. She lives in Dayton, Ohio, with her kids and husband of over twenty-five years but is a southerner at heart. Face fear and embrace confidence at www.JessicaBettencourt.com.